The Best of Pastel 2

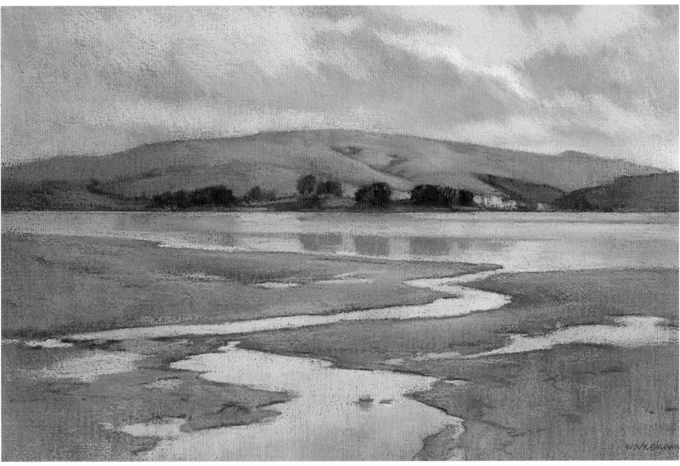

Duane Wakeham *Tomales Bay, Low Tide*

First published in the United States of America by:
Quarry Books, an imprint of
Rockport Publishers, Inc.
33 Commercial Street
Gloucester, Massachusetts 01930-5089
Telephone: (978) 282-9590
Fax: (978) 283-2742

Distributed to the book trade and art trade in the United States by:
North Light, an imprint of
F & W Publications
1507 Dana Avenue
Cincinnati, Ohio 45207
Telephone: (800) 289-0963

Other Distribution by:
Rockport Publishers, Inc.
Gloucester, Massachusetts 01930-5089

ISBN 1-56496-448-5

10 9 8 7 6 5 4 3 2 1

Designer: Lynn Pulsifer
Cover Image: Joe Hing Lowe *Yoga Pose* (see page 80)
Back Cover Images: Janet Hayes *Still Life with Quinces (top)*
 Frank Zuccarelli *Venice Afternoon (bottom)*

Front Flap Image: Roz Hollander *Silver Queen* (see page 15)
Back Flap Image: Alden Baker *Arrangement in Blue and Orange* (see page 29)

Manufactured in China.

The Best of Pastel 2

GLOUCESTER MASSACHUSETTS

QUARRY BOOKS

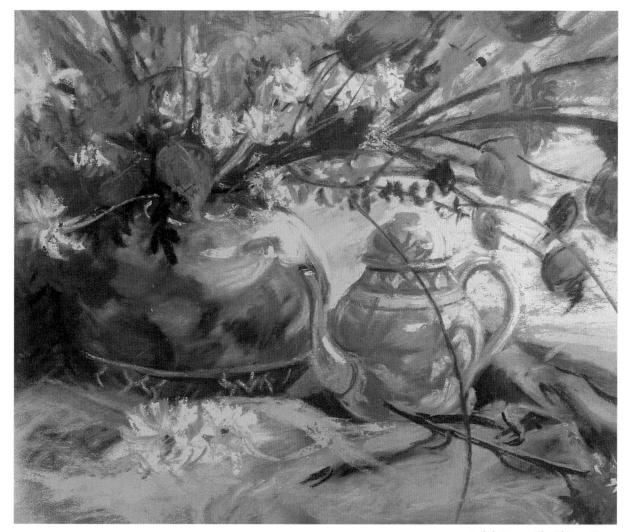

Judith Scott *The Chinese Teapot*

Selected by The Pastel Society of America
Edited by Kristina Feliciano

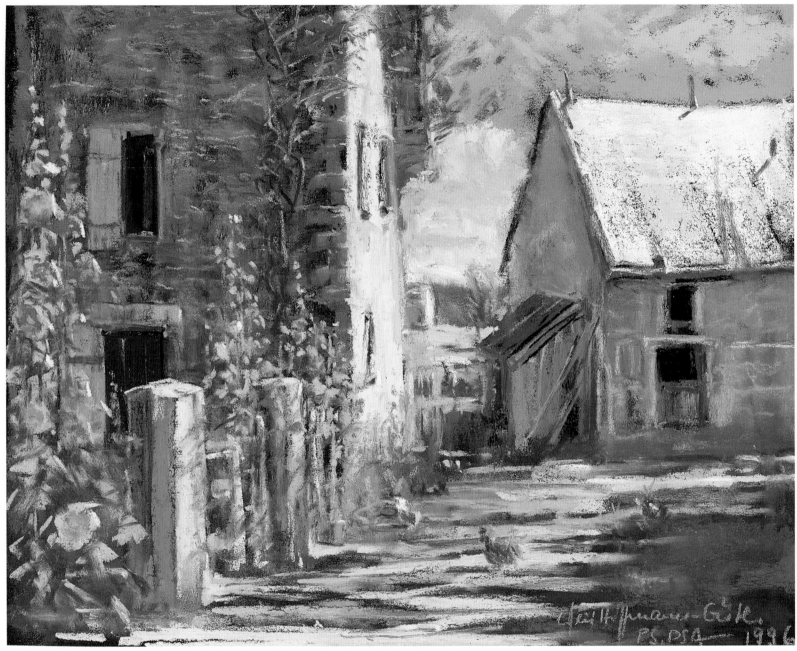

Willi Hoffmann-Guth *Brittany Farm (near Paimpol), France*

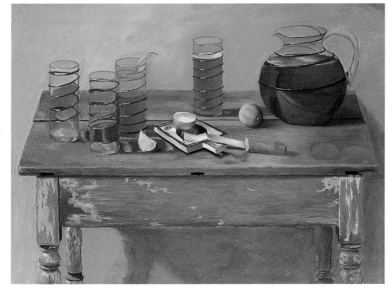

Peter Seltzer *Summer*

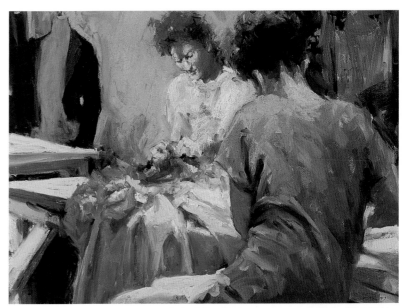

Jody dePew McLeane *Seamstress at the Work Table*

Introduction

Before the Pastel Society of America (PSA) was founded in 1972, we pastelists had no real home of our own. We were showing our work alongside that of watercolorists in exhibitions sponsored by the American Watercolor Society (AWS) at the National Academy of Design in New York City. Eventually, however, even that opportunity ceased. The AWS's reigning president decided that too many prizes were being won by pastelists, representing a major loss for watercolorists. So pastelists were no longer permitted to show with the AWS. What were we to do? After some deliberation, we decided to establish our own identity and create an organization dedicated to pastelists.

This was not going to be easy, though. Others had tried and failed. In 1882, William Merritt Chase had attempted to form the country's first pastel society—a group he named Painters in Pastel. Unfortunately, the organization lasted only six years. In quick succession, other such groups were formed and disbanded. We alone have survived, and in 1997 we observed our 25th anniversary.

During the past quarter century, we have experienced increasing success and have re-ignited an interest in pastels among both artists and collectors. And, although at the time it was founded ours was the only organization of its kind in the United States, we have since guided the formation of more than thirty pastel societies in the country.

We keep our members informed of events and opportunities through our biannual publication, the *Pastelagram*, and a monthly newsletter called *Alert*. We hold annual member and non-member exhibitions, maintain a slide registry of work to promote sales, and each year select outstanding pastelists to our Pastel Hall of Fame.

Not content to rest on our laurels, we launched another innovative venture, a school called For Pastels Only. The school has flourished, expanding to offer morning, afternoon, and evening classes with teachers specializing in portraiture, the figure, landscapes, cityscapes, still lifes, and florals. Enrollment in these classes is limited, so we can ensure that students receive personal attention. The school's handsome studio is located in the elegant landmark building of the National Arts Club in New York City, which has also served as the PSA's headquarters since its inception.

The school's five award-winning instructors (Christina Debarry, Flora Giffuni, Sidney Hermel, Richard Pionk, and Rhoda Yanow) are all well-informed in the latest pastel technology, as well as in the basics and advanced artistry of the specialties they teach.

For more information on our school, membership in the PSA, or the PSA itself, please call the PSA office at (212) 533-6931 between 10 a.m. and 5 p.m. Wednesday through Friday; or write: Pastel Society of America, 15 Gramercy Park South, New York, NY 10003.

In the meantime, we hope you enjoy this book, which features work by some of the finest award-winning members of the PSA, as well as a chapter on how to critique your own artwork, by PSA Board Member and Critiques Chairperson Alden Baker.

Flora B. Giffuni, Founder and Chairperson
Sidney Hermel, President Emeritus
Christina Debarry, President

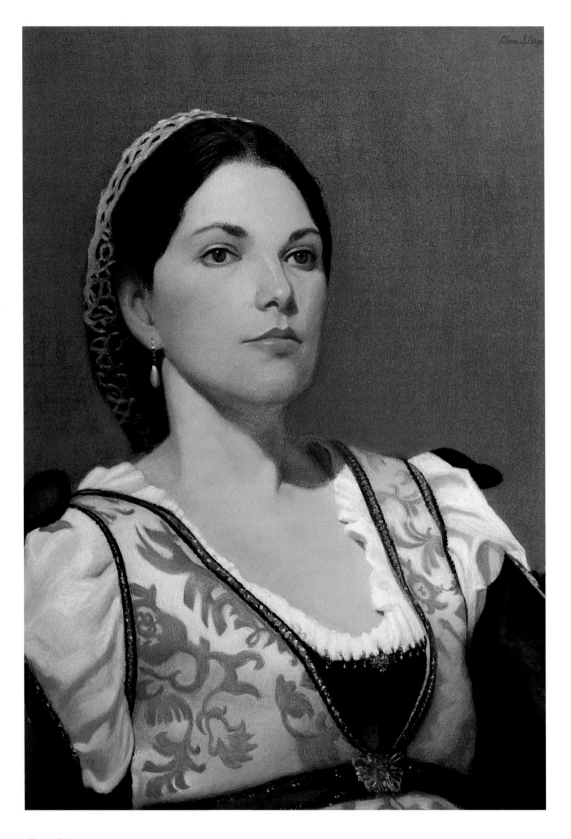

The model I used for this painting belonged to a historical society. They put on plays and exhibitions wearing the clothing of long ago. I imagined the model to be a lady in waiting at the court of Henry VIII. I placed her higher than my eye level to give the feeling that she was sitting on a throne and aimed to have her expression show confidence and good breeding.

Dan Slapo
My Fair Lady

24 x 20 in. (61 x 51 cm)
Surface: Canson Mi-Tientes pastel paper, Steel-gray

Since he is viewing the model from the lighted side, Slapo uses high-key values and applies a few darks on the far side of the face: the eye socket, the nose shadow, and the neck shadow. He makes the top of the clothing very light in contrast to the area below to give the impression of a satin finish.

To me, setting up a still life, choosing the objects for their shape, color, and texture, and arranging them in an interesting fashion is a creative effort in itself. I have several bookcases in my studio filled with possible subjects.

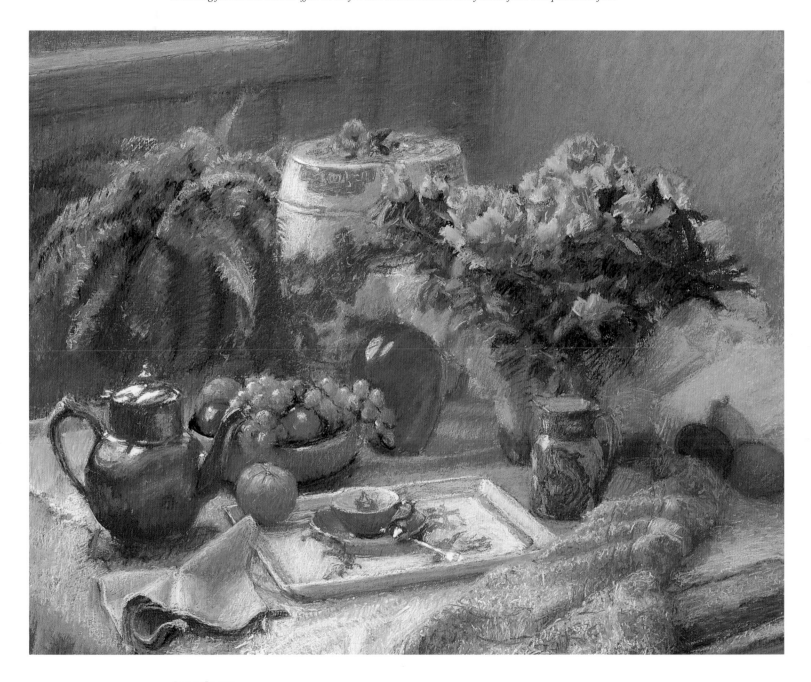

Jane Scott
Against the Light

30 x 36 in. (76x91 cm)
Surface: Crescent board

Scott works with the ends of her pastel sticks, almost never painting with the sides. She also does not use fixative, and does not rub the surface to blend colors. She simply layers colors one over the other, pushing for the brightest hues she can.

Flowers have always been a source of delight for me. I love their many marvelous forms and textures, their variety of scents, and shades of colors. Fresh blossoms in my home or in my garden reaffirm for me nature's wondrous power of rebirth in every season of the year. Fresh flowers have the power to uplift one's spirit even on a dreary day.

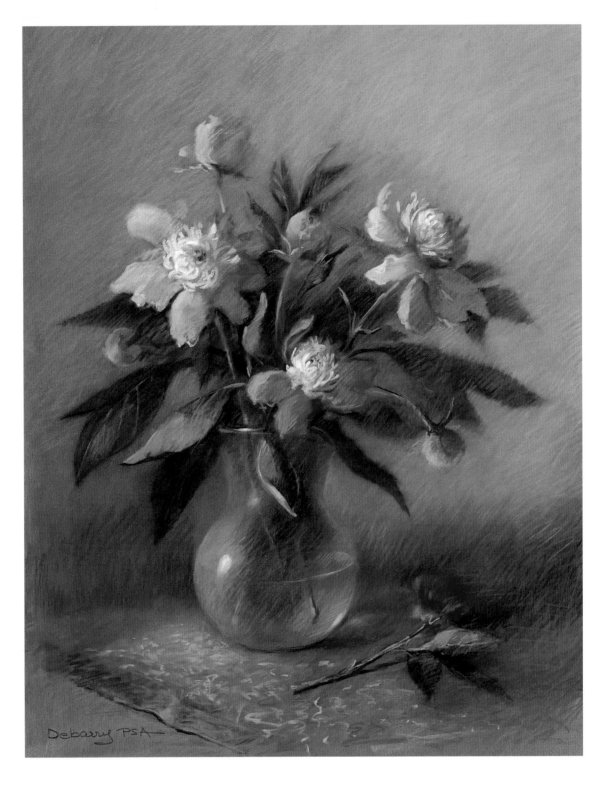

Christina Debarry
Pink Peonies

24 x 18 in. (61 x 46 cm)
Surface: La Carte pastel paper, Van Dyke brown

Debarry uses thumbnail sketches to establish the composition of her paintings. Then, working from direct observation, she weaves color together in as many as ten layers. She makes it a point not to blend too much with her fingers, instead blending colors by cross-hatching and glazing.

I have tried to capture the simplicity of everyday life: two women passing the time of day. Although I have used various themes from the many Caribbean islands, I often come back to the image of the brightly attired female.

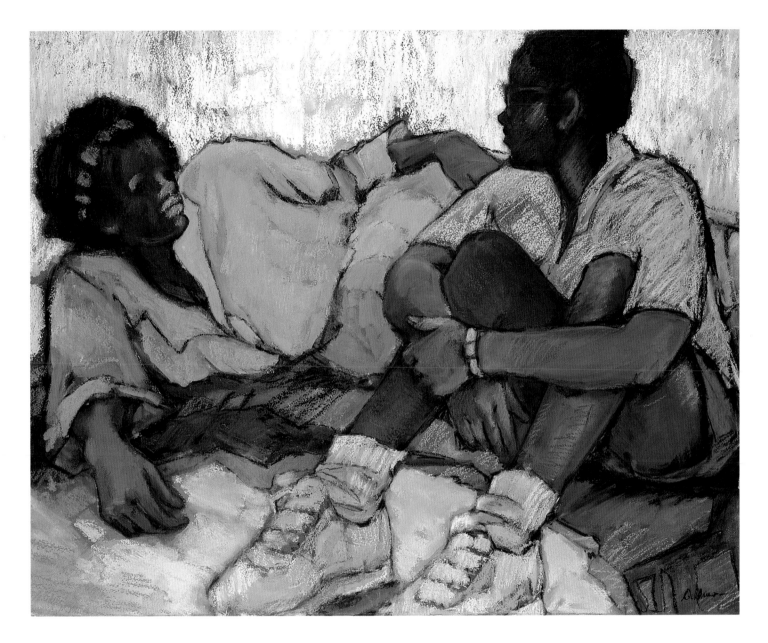

Connie Dillman
Best Friends

30 x 40 in. (76 x 102 cm)
Surface: 300 lb. watercolor paper

Dillman gets much of her subject matter from the Caribbean islands, whose bright colors and residents inspire her to experiment with her pastels.

In Dream Peace, *I am touching on the need for respite, renewal, and inspiration. The cool blue, gray, and white tones and cloth folds envelop the body with softness, enabling one to achieve this respite.*

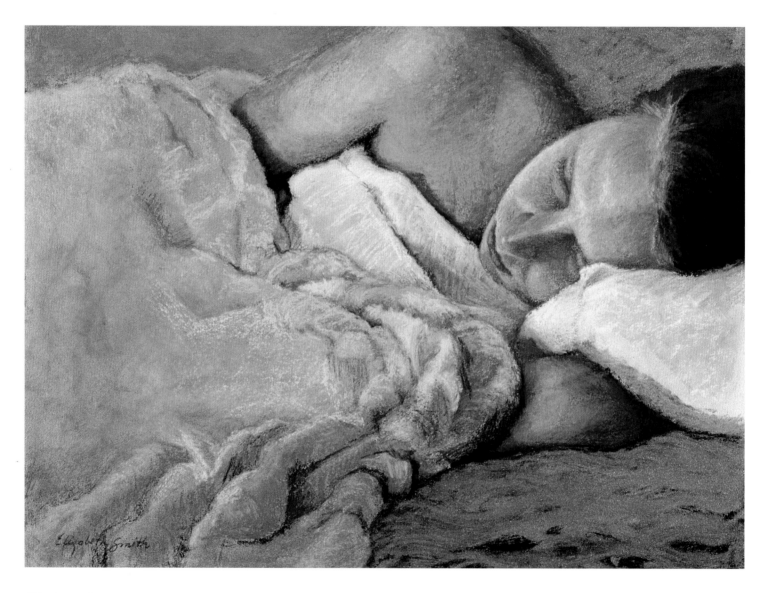

Elizabeth Smith
Dream Peace

14 x 19 in. (36 x 48 cm)
Surface: Whatman illustration board

Smith first develops the dark green areas and notes the deepest dark she will use as well as the lightest light. She then gauges all her tones according to these parameters.

The northern New Mexico landscape is home to me. The high altitude and clear skies lend a crispness to the buildings and landscapes that soft pastels capture beautifully.

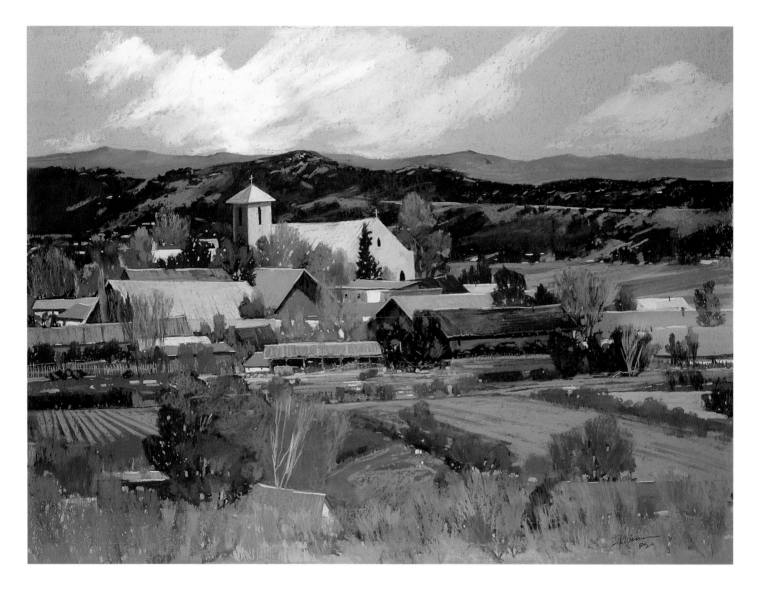

Dinah K. Worman
Tierra Amarilla

23 x 33 in. (58 x 84 cm)
Surface: Ersta sanded pastel paper

Worman uses diagonal fields of pastel to draw the viewer's eye to the cluster of buildings that make up the small village. The church steeple reaches up into the mountains to tie the upper third of the painting containing the sky and the mountains to the earth. She makes sure that some trees bisect the plains, to keep the painting from looking as if it were composed of bands of subject matter.

11

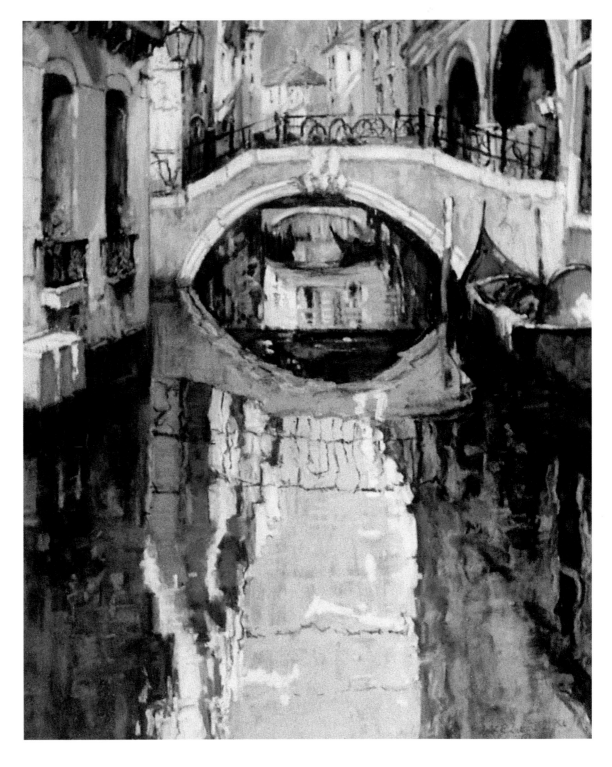

I was fascinated with the reflections of the buildings in the water, the brilliant sunlight, and the antiquity of the architecture in Venice. I was also fascinated by being able to stand in some of the places that possibly Canneleto stood or where Richard Parks Bonnington had painted.

Frank Zuccarelli
Venice Reflections

30 x 24 in. (76 x 61 cm)
Surface: Arches BFK Rives pastel paper, Gesso pumice

For this work, Zuccarelli first creates a watercolor underpainting to establish color patterns. After the watercolor dries, he uses hard pastels to glaze additional color in corresponding hues, such as blues, violets, and greens. In the light areas, he applies the pastel with staccato strokes to create a textural effect.

I like the female figure—I find it very graceful. In this case, I had a general plan for the composition in mind when I started, and I posed the model to fit my plan.

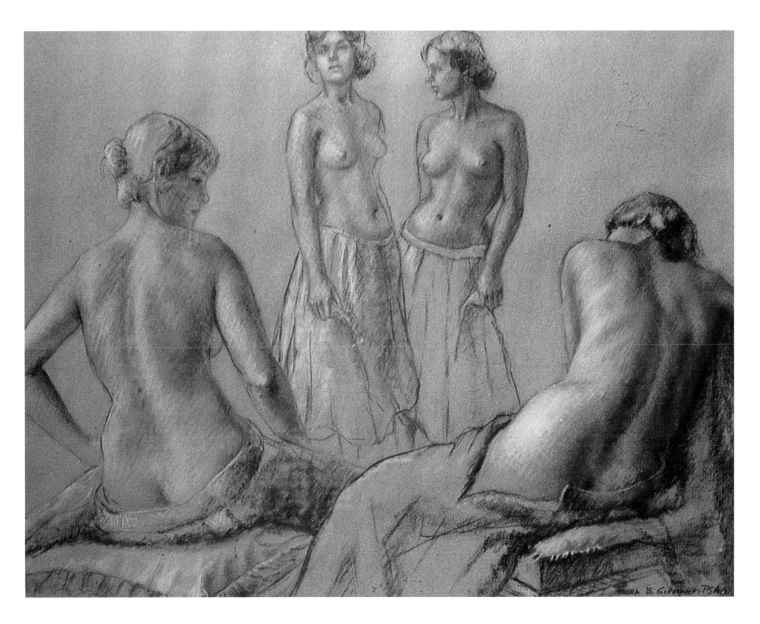

Flora Giffuni
The Four Graces

24 x 36 in. (61 x 91 cm)
Surface: Canson Mi-Tientes pastel paper

Giffuni considers a strong drawing and composition essential. Here, she draws four poses of the same model, planning the poses carefully to create a composition that will be both compelling and well balanced. She cross-hatches the final layer of pastel so that the colors beneath are still visible but the shadows and lights are enriched.

This work is from a series on lawn bowlers. The fact that they were dressed in white allowed me to plan the composition tonally. Everything in the painting was reduced to shapes as opposed to color, so you have shapes of hats, and shapes of shirts, and shapes of bodies. I wasn't interested in the sporting event. These people were eating lunch on a bench during a break. I'm interested in people in everyday situations—the business of living.

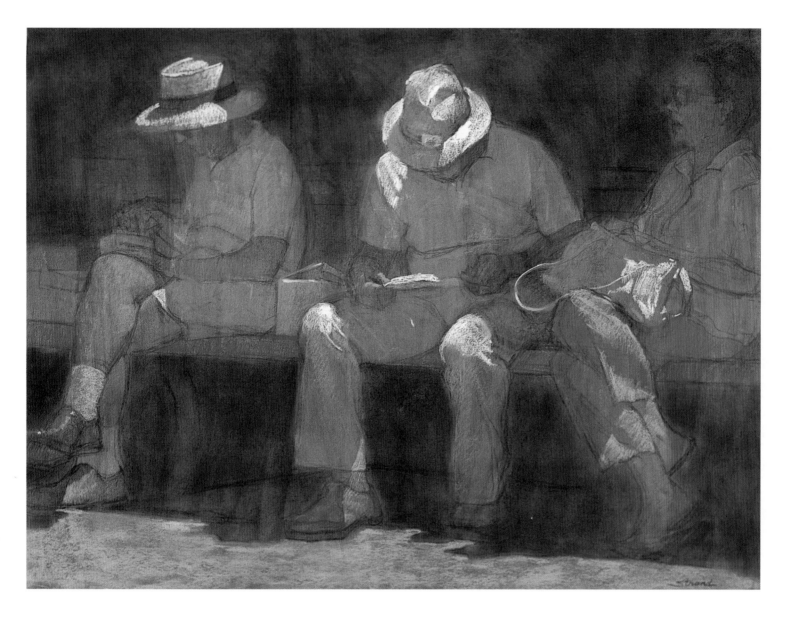

Sally Strand
Player Series #2

22 x 30 in. (56 x 76 cm)
Surface: Arches BFK Rives pastel paper

Intrigued by the way parts of the figures were in shadow and others were in light, Strand focuses on value more than color. She applies the pastel thinly, building it up only slightly in the light areas, and paints the scene according to what she calls a three-tone plan: a pattern of lights, a pattern of middle tones, and a pattern of darks.

I live in the country, where there are lots of cornfields. I look forward to the end of summer, about mid-August, when the corn is ready to be picked, fresh from the fields, and sold at roadside stands.

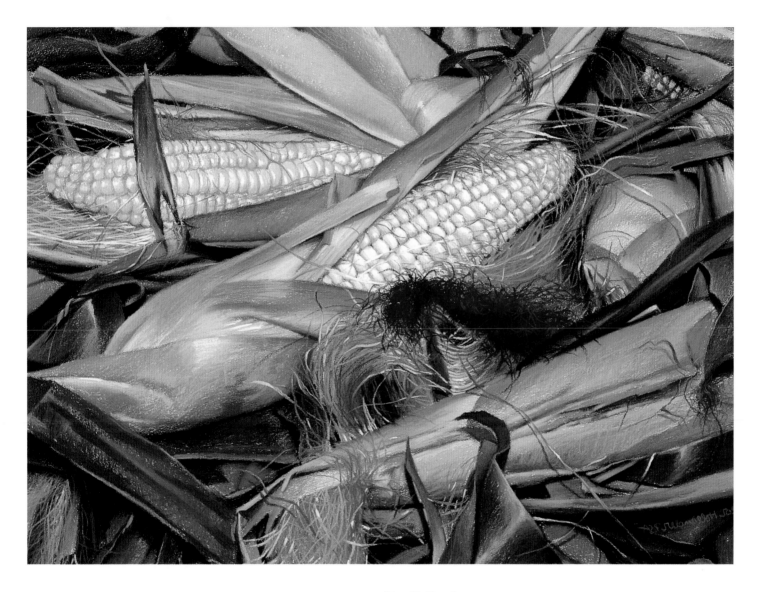

Roz Hollander
Silver Queen

21 x 28 in. (53 x 71 cm)
Surface: Arches printmaking paper

Hollander generally starts with a drawing in black pastel, which she then sprays with workable fixative. Next, she applies a layer of color over the entire surface and wets it with water and a rag. When this layer is dry, she builds up the painting in soft pastels.

I grew up on a tree-lined street in Brooklyn, New York, and I always admired the trees, even before I learned how to draw. Winter is my favorite time to paint them, since the leaves are gone and I can see the skeletons of the trees and their beautiful inner rhythms. In this instance, the winds from the Pacific Ocean have markedly shaped these trees in a distinct and beautiful way.

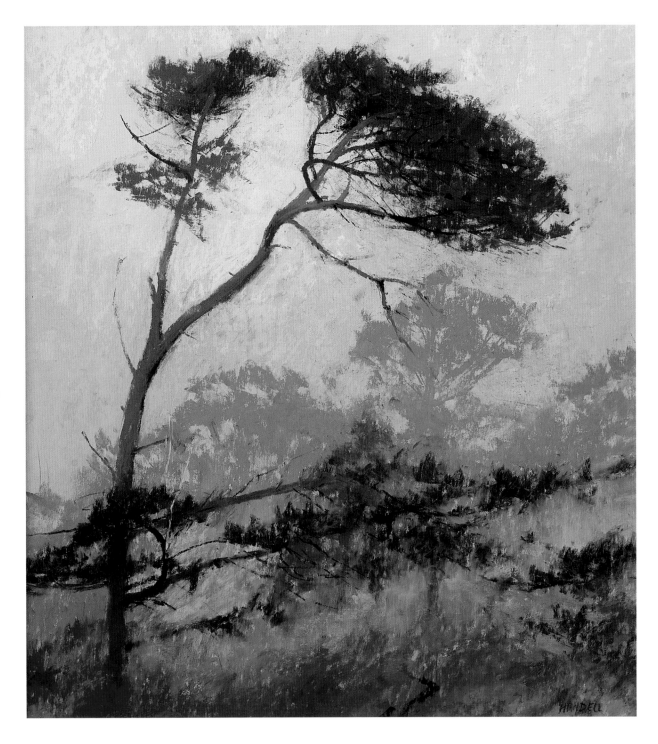

Albert Handell
Coastal Fog

15 x 14 in. (38 x 36 cm)
Surface: Wallis sanded pastel paper on museum board

Working on location on California's Monterey Peninsula, Handell achieves the subtlety in this painting by using colors that are similar in value. In fact, he finds that, in general, by varying hues rather than values, he can produce beautiful color and create an accurate sense of light.

The sad incongruity of fellow humans living like pigeons in a peaceful park in the world's wealthiest nation struck me. Compositionally there was nothing I wanted to place in the lower right-hand corner, so I eliminated that corner. I felt the impact of the curved benches was heightened by this irregular shape.

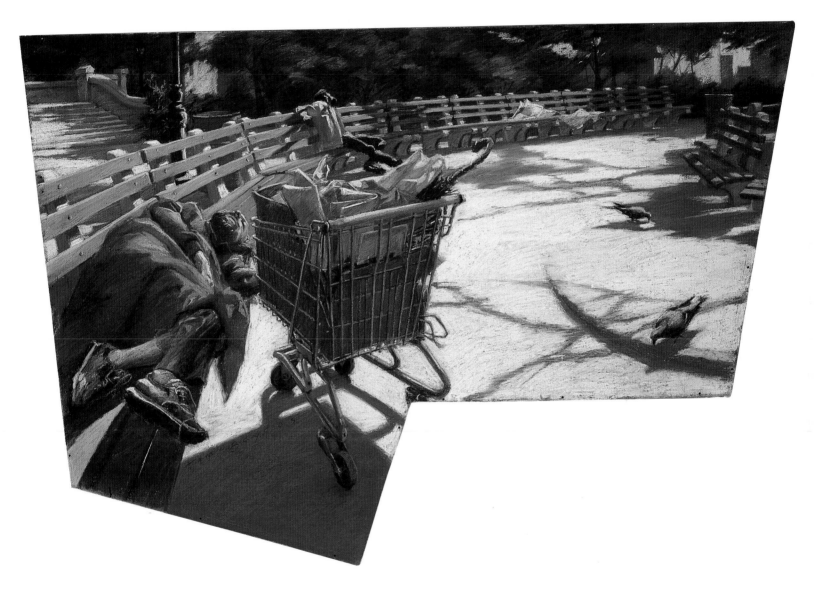

Tim Gaydos
Morning in the Park

30 x 42 in. (76 x 107 cm)
Surface: Luan plywood

Gaydos developed this painting from a sketch he had made in the early morning in Tompkins Square Park in New York City as well as from separate sketches of a model posed on a park bench, pigeons, and another figure.

17

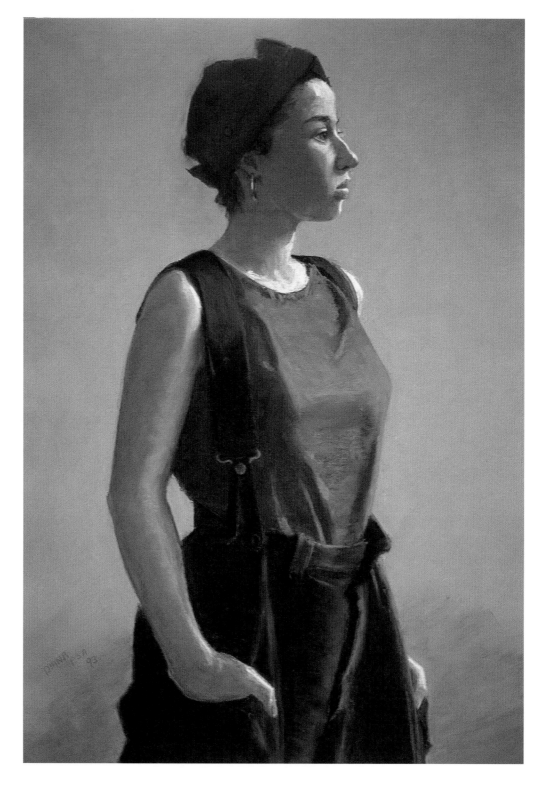

Diana DeSantis
Anya

36 x 28 in. (91 x 71 cm)
Surface: Arches hot-pressed watercolor board

For her figure paintings, DeSantis makes a detailed drawing and then applies a layer
of yellow ochre pastel, regardless of the model's skin tone.

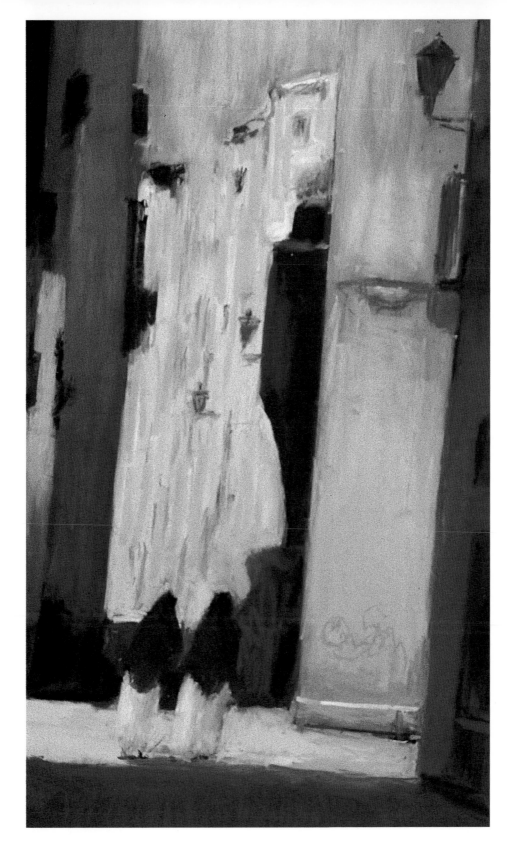

I was walking in Toledo, Spain, and saw this streak of light across the buildings. Two nuns walked into the light, and I was stunned by the way the sun shone on their clothing. With no time to sketch, I quickly grabbed my camera and took a single photo. From that photo I developed this painting, starting first with a water-color painting to get the shapes, shadows, and light.

Sidney Hermel
Toledo No. 2

27 x 21 in. (69 x 53 cm)
Surface: La Carte pastel paper, No. 12 gray

Hermel prefers to concentrate on the interesting shapes that make up a scene rather than focus on repro-ducing its exact details. In this painting, he emphasizes the sunlight on the buildings and the nuns, using yellows, yellow ochres, and orange. For the nuns' habits, he applies white pastel over a yellow underpaint-ing to warm up the light.

I did this pastel from an old oil painting of mine. I've always played chess—I love it.

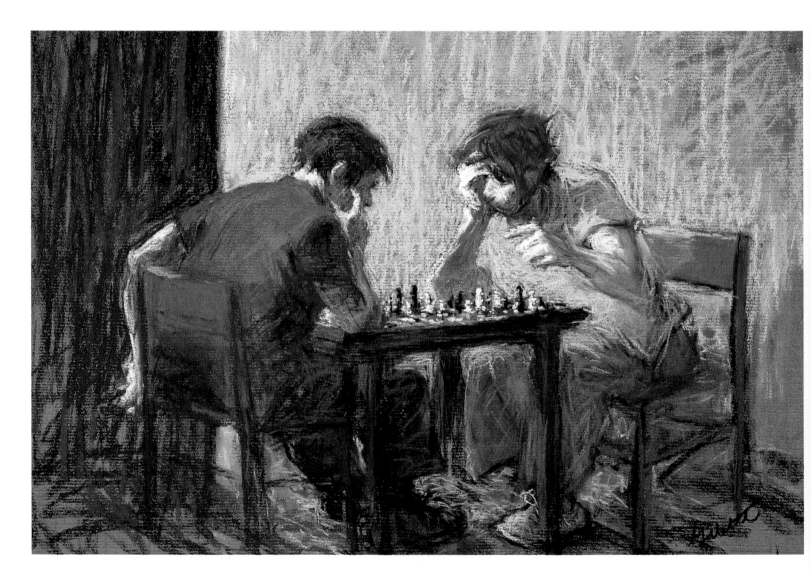

Henry Gillette

The Move

25 x 35 in. (64 x 79 cm)
Surface: Fabriano Roma handmade pastel paper

Gillette says he works from memory and imagination. Technique, he says, is not the focus of his paintings.

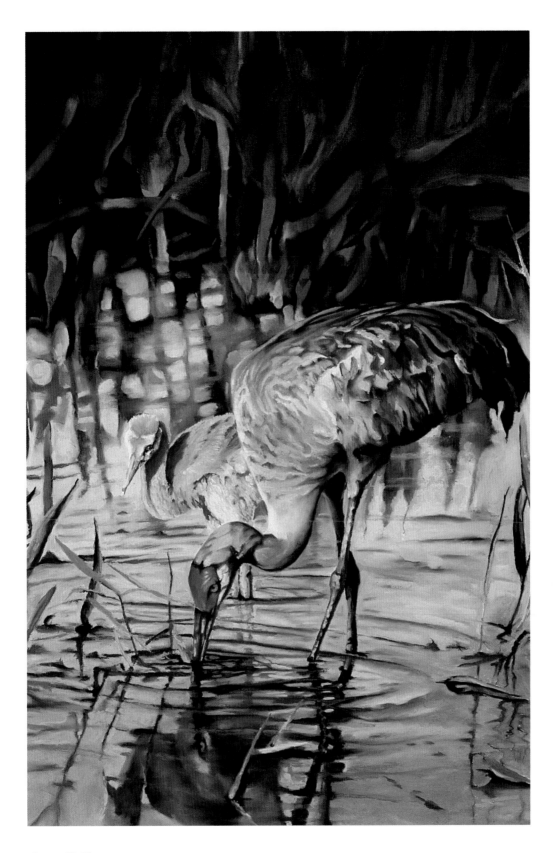

I remember I sat about ten feet away and watched these birds come toward me in the marsh, and I just started photographing them. I can recall that moment to this day, how wonderful it was to see this sandhill crane teaching its young to feed.

Janet N. Heaton
The Lesson

40 x 28 in. (102 x 71 cm)
Surface: Schoellershammer 100% rag board

Heaton, a wildlife painter, does a great deal of research in the field for her paintings. She works from photos she's taken herself, notes, and sketches.

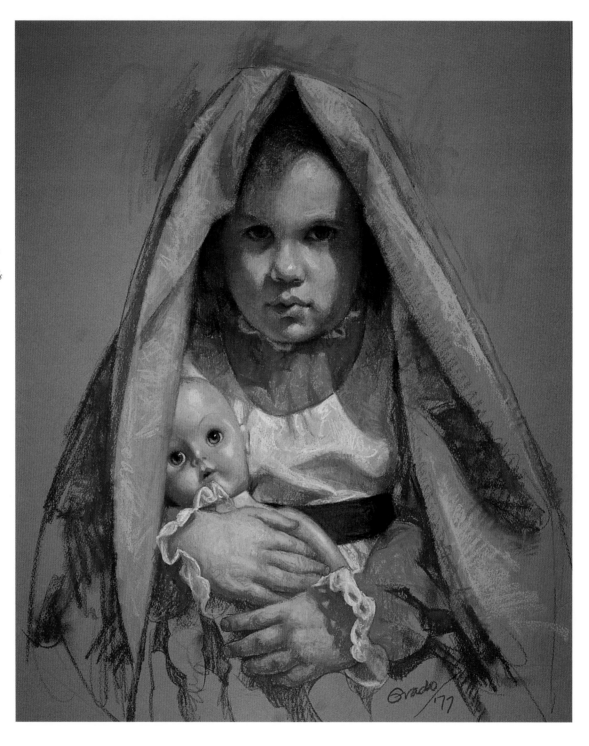

I had just completed several pastel portraits of young girls and decided to paint my granddaughter Megan. She would not cooperate for a formal painting, so we had to play-act. I had to pose her as a mother with her child, which she thought was more fun.

Angelo John Grado
Little Mother

24 x 20 in. (61 x 51 cm)
Surface: Canson Mi-Tientes heavyweight pastel paper, Sand color

Grado's paintings tend to be studies in texture—in this case, the drapery, which he paints loosely, and the girl's face, for which he uses a smoother technique.

I was attracted to the brilliant color and unusual composition of this scene. The couple relaxing in the chairs add to the atmosphere of comfort.

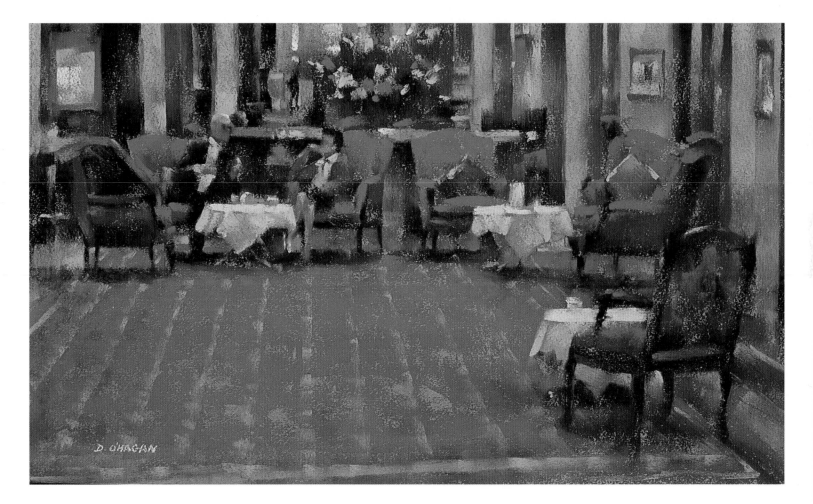

Desmond O'Hagan
Lobby of George V, Paris

11 x 19 in. (28 x 48 cm)
Surface: Canson Mi-Tientes pastel paper

O'Hagan conveys the warmth and luxury of this scene by applying the pastels in loose strokes and adding touches of intense reds.

My figurative pastels are abstracted psychological portraits rather than straightforward renderings of the subject. This work is derived from several visits I made to the costume shop of a Milwaukee theater. I have heightened the light to make it theatrical, illuminating the mood of the figure.

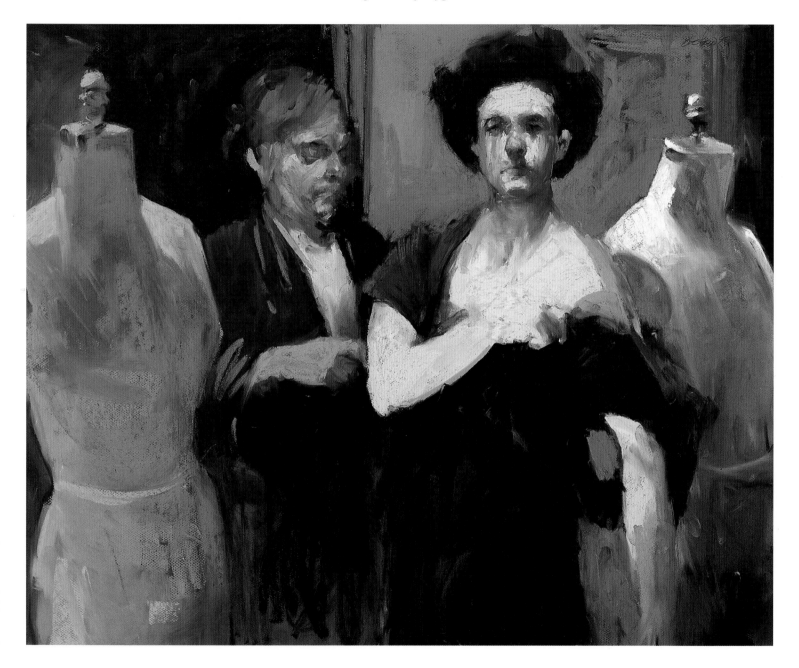

Jody dePew McLeane
Dressing the Heroine

26 x 32 in. (66 x 81 cm)
Surface: Canson Mi-Tientes pastel paper

McLeane uses her hand as a palette of sorts, crumbling the pastels in her left palm and scooping up the pigment with her right thumb to apply it to the paper. This technique gives her work a painterly quality. When she completes a painting, she steams it to fix the pastels as opposed to spraying it with fixative.

I seldom paint nature as I see or photograph it, but on a recent trip to Normandy—a place I dearly love—these trees called to me. It was as if they were a natural still-life arrangement waiting to be painted.

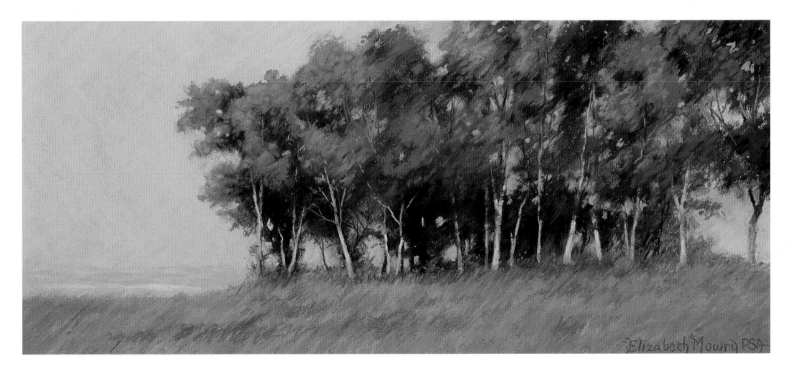

Elizabeth Mowry
Trees, Normandy

8 x 18 in. (20 x 46 cm)
Surface: Ersta sanded pastel paper

For this painting of trees in summer, Mowry uses a simple palette. She considers this condensed composition an example of the strength a work of art can have when it is limited to a single, undiluted idea.

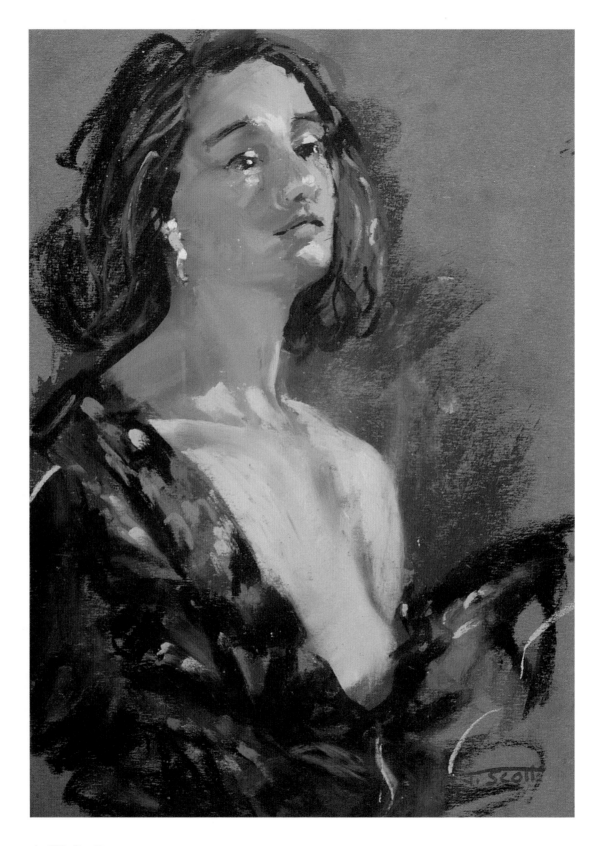

Just Colors is one of those paintings I wish I could do more of. Actually, I did three in a three-hour session with a model, but only in this one was I able to keep the freshness of the pastel. I have recently learned that if I keep moving my eyes around the model or scene (in the manner of the famous artist and teacher Emile Gruppe), my colors will look fresher and will not blur or neutralize.

Judith Scott
Just Colors

10 x 8 in. (25 x 20 cm)
Surface: Ersta 700 sanded pastel paper

Scott used the most intense colors she can to build this painting up. Her painting process is direct—she does not smear and smudge the extremely soft pastels she chooses but instead lays them in thickly and with pressure.

This was painted at my favorite garden before it was decided that a freeway should run through it. (Painful, indeed!) To me, gardens represent optimism and joy in life. Peace and joy combined are what I would like to express in my art.

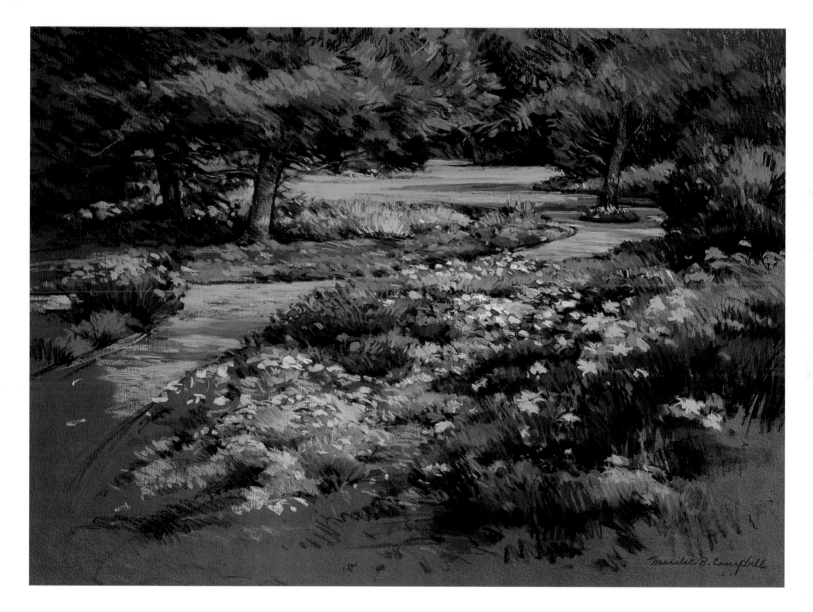

Marilee B. Campbell
Morning Walk

18 x 24 in. (46 x 61 cm)
Surface: Ersta sanded paper, Gray-green

Because the paper is toned, Campbell makes her drawing bold. She blocks in the image with black to provide the structure on which to "hang" the colors, and she lets the paper show through in areas.

27

There was something fascinating about the man who posed for this portrait—something strong, yet vulnerable; something fierce, yet gentle. He was a man of contrasts, of light and darkness—but mostly of light. There was the challenge: to render with the right balance his somber aspect, his intensity and inwardness, the solidity of this Italian man born at the foot of the Etna. I left the background almost bare, and one might think it abnormally wide and empty. And one would be right; it was deliberately planned this way to accentuate the solitude of the man.

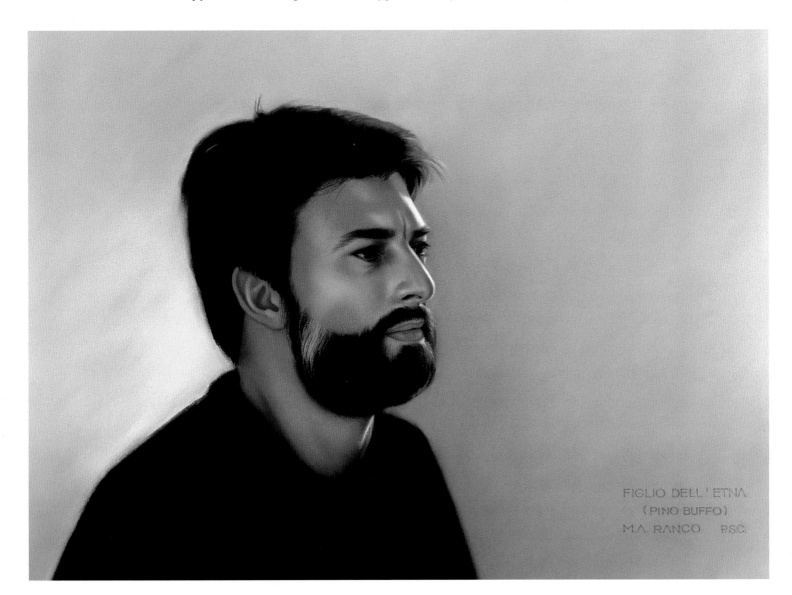

FIGLIO DELL' ETNA
(PINO BUFFO)
M.A. RANCO P.S.C.

Marilyn-Ann Ranco
Figlio dell' Etna (Son of the Etna)

13 x 16 3/4 in. (33 x 41.5 cm)
Surface: La Carte pastel paper, Beige

Ranco was most interested in capturing the way the daylight contoured her subject's face. In fact, she repainted the light several times before she achieved the exact hue and color temperature she desired.

When I found the colorful, striped fabric that I used as a background for this still life, I knew it would successfully unite some of the orange and blue bowls and pots I had on hand. I took great pleasure in finding all the nuances of reflected color from the fabric.

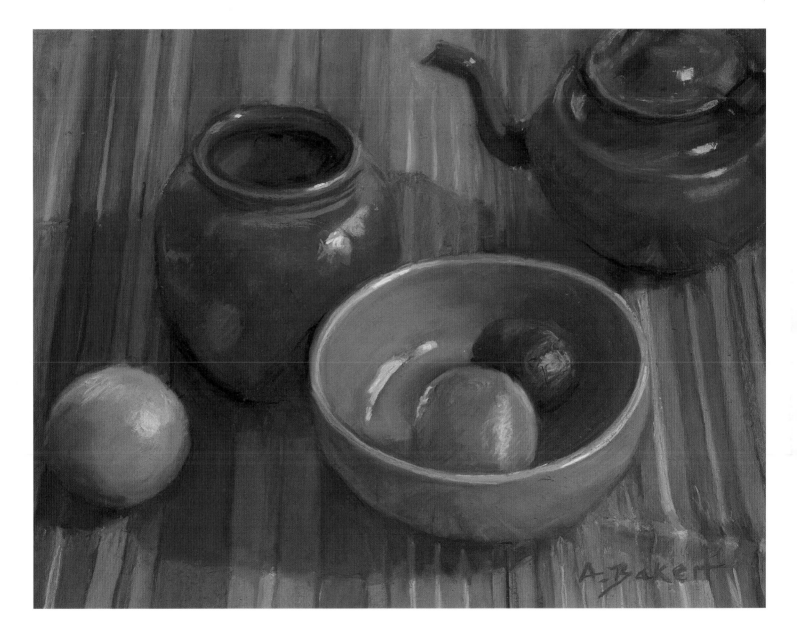

Alden Baker
Arrangement in Blue and Orange

18 x 25 in. (46 x 64 cm)
Surface: Canson Mi-Tientes pastel paper

For this painting, Baker uses a colored pastel paper because it provides a tone on which to work out the values. She achieves intense colors by bearing down hard on the pastels as she paints.

To me, a painting is a success when it is intriguing even though it depicts a subject that people would normally skim over. Fruit Cups II, which was inspired by the beauty and geometric quality of light on the subjects, stresses the poetic aspect of such overlooked objects. I used color and texture to convey the positive feeling that sunlight coming through a window gives.

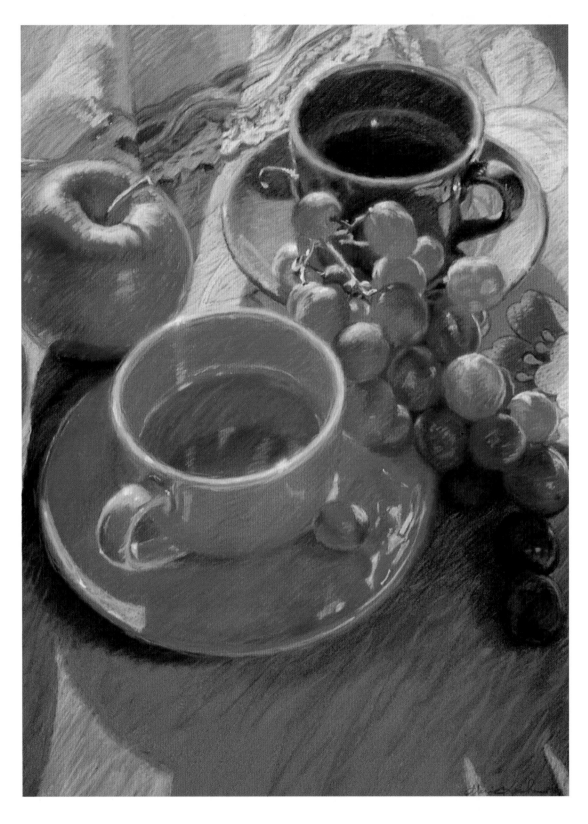

Marie Kash Weltzheimer
Fruit Cups II

24 x 18 in. (61 x 46 cm)
Surface: La Carte pastel board

Weltzheimer wove and layered the colors in the painting to make it more vibrant and visually complex.

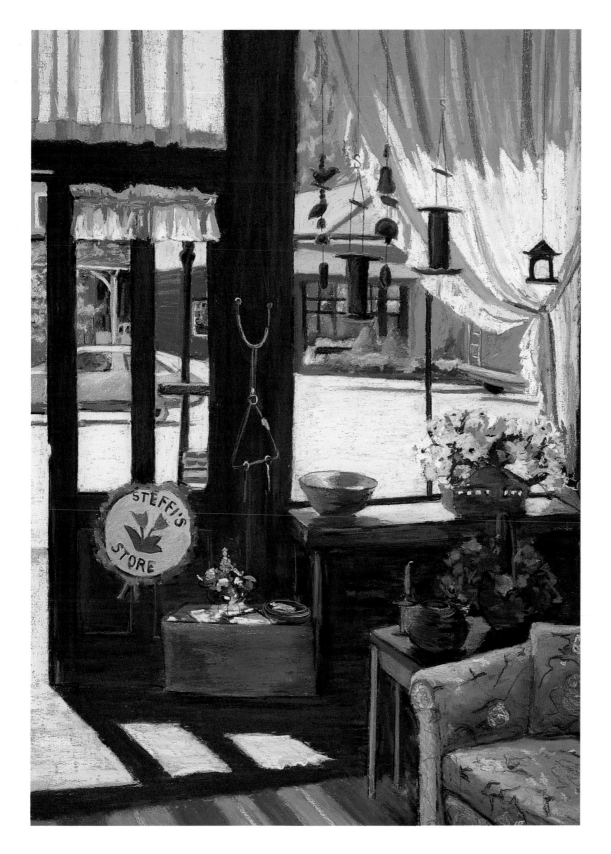

A recurring theme in my work is interior scenes that incorporate outdoor elements, such as views through windows or doors. This painting is of a store I came across in a small northern Georgia mountain town.

Martha Bator
Steffi's Store

37 x 27 in. (94 x 69 cm)
Surface: Treated luan board

Here, Bator focused on contrasting the bright light outside the store with the shadows inside.

I was intrigued with the idea of painting a carousel and the carousel horses because they're infinitely interesting. They're incredibly colorful and undulating. But then I wound up including a child who was absolutely taken with this fantasy ride. I love children, and I was really taken up in this child's fantasy, in effect. I went to the carousel with the idea that the animals would be so interesting for a painting, and yet this child was the springboard for the image. His fantasy was what I became a part of and wanted to re-create.

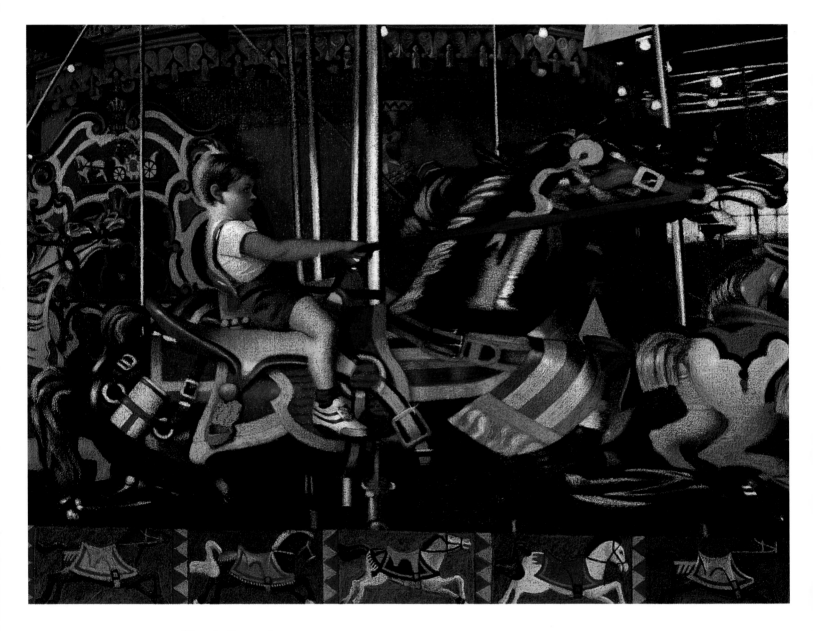

Wende Caporale
Child on Carousel Horse

30 x 40 in. (76 x 102 cm)
Surface: Canvas

Caporale chose to distort the carousel to simulate movement, which posed quite a technical challenge. To achieve it, she shot photographs of an actual carousel and distorted the images in the darkroom. She used these as references for her painting.

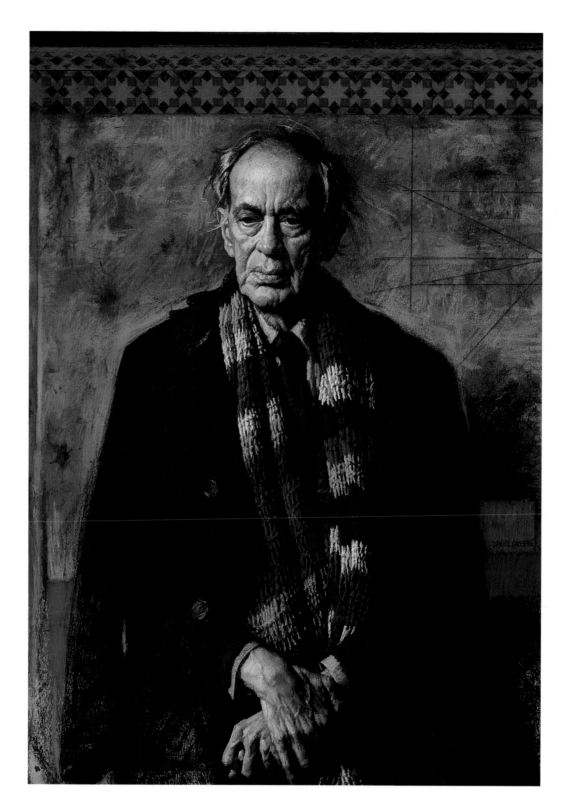

When the renowned teacher of anatomy and drawing, Robert Beverly Hale, came to pose for me, he was quite elderly, weak, and frail. At first I chose a seated pose with a position elevating his beautiful, lean hands, but he couldn't hold his hands up and I wasn't able to get them in the picture. So I decided to do another picture of him standing. My reasoning was that he could drop his arms at his side and they could easily be included in this vertical format.

Daniel Greene
Robert Beverly Hale

50 x 36 in. (127 x 91 cm)
Surface: Granular board

Greene uses several decorative elements in this stately picture: The background is meant to simulate gold leaf, and the decorative border at the top of the work is based on fifteenth-century Flemish tempera paintings.

Muslim Maidens *is an exercise in white: white clothing on a white background. The faces of the women force-fully contrast with the rest of the painting and, therefore, are of principal interest. This painting is a companion piece to a painting entitled* The Rabbis, *which is a study of black on black, with the faces and beards of the rab-bis the strongest pictorial element.*

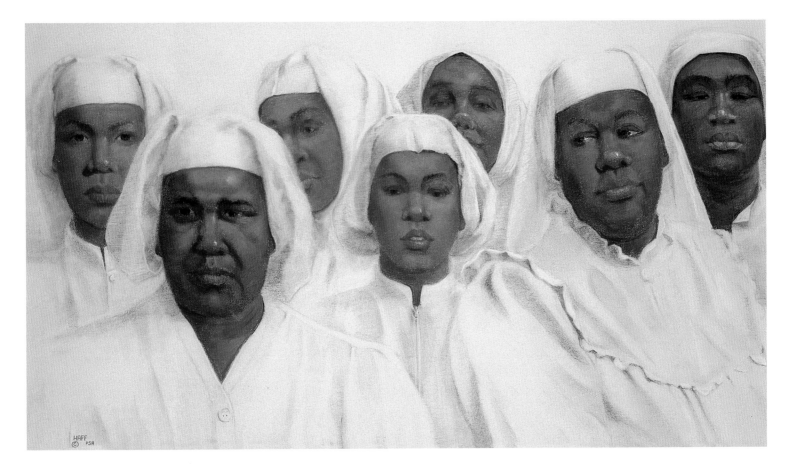

Barbara Haff
Muslim Maidens

20 x 34 in. (51 x 86 cm)
Surface: Canson Mi-Tientes pastel paper, White

In this painting, Haff concentrates primarily on the focal points—detailed renderings of the faces—and then develops the rest of the painting around them.

I think this painting has a peaceful quality. The colors are not garish. I tried to keep them as soft as possible, which I think is very soothing.

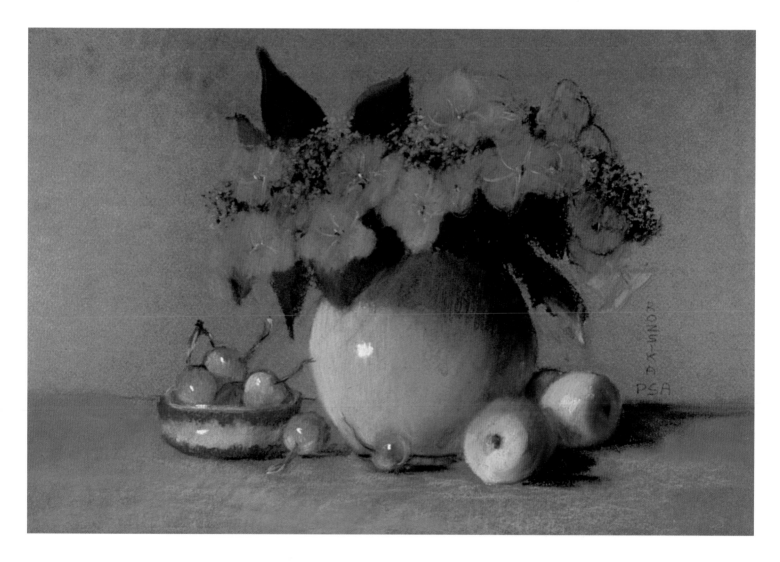

Rozsika Ascenzi
Hydrangea, Apricots, Cherries

20 x 26 1/2 in. (51 x 67 cm)
Surface: Canson Mi-Tientes pastel paper, Ivy green

Ascenzi wanted to make a painting that featured the hydrangea bush in her backyard, as she was inspired by its colors. She found the creamer and cherries in a market and thought they'd be perfect for the painting. Later, she included the apricots for additional color.

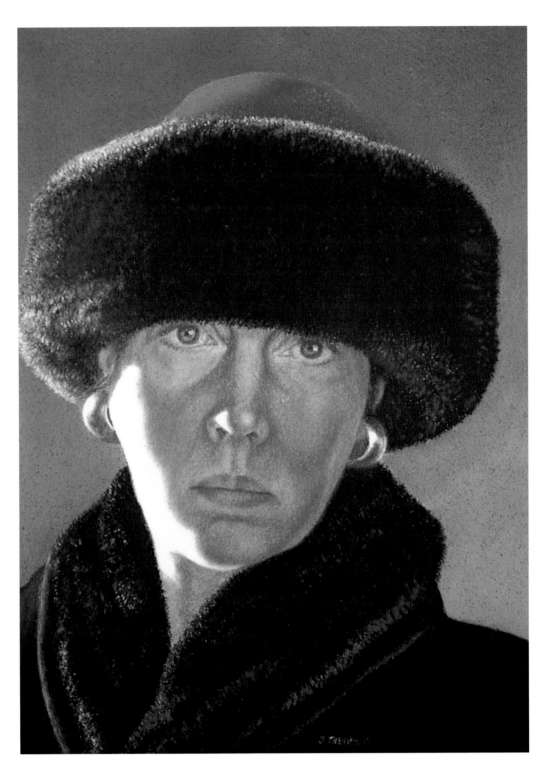

I've made many self-portraits over the years, perhaps just to confront and scrutinize myself. I always work from direct observation, which was slightly tortuous in this particular case because of the warm winter garments and the heat generated from my studio spotlights.

Janis Theodore
The Snow Hat

14 x 10 in. (36 x 25 cm)
Surface: Canson Mi-Tientes pastel paper, Green-gray

Theodore carefully works out the composition for this self-portrait, making sure the image fills the page. She then does a light drawing in charcoal pencil to render the features correctly.

This shop is located in my neighborhood. I photographed it one day with the deep shadows and the brilliant sunlight spattered across the sidewalk. I was also intrigued by the many reflections of the cars and other buildings in the window.

Jo Ann Leiser
The Flower Stall

24 x 18 in. (61 x 46 cm)
Surface: Gessoed board

Leiser likes to paint on gessoed board because it inhibits the ability to make hard edges, resulting in a more painterly effect.

Sue was a cute 16-year-old when she posed for my portrait class. Her shyness fascinated me. She was looking at one of my nudes when I asked her to pose for me. She agreed but said, "Just my shoes, though."

Hal English
Just My Shoes

25 1/2 x 18 in. (65 x 46 cm)
Surface: Canson Mi-Tientes pastel paper

English describes his technique as being "no technique at all." He always paints with the same kind of pastels, and always on the same kind of paper.

I love to paint en plein air with pastel, the kind of small painting where I'm noting the features of the landscape. A site is never the same twice. One never knows what to expect. It is like a gift each time, and never to be taken for granted. When the viewer sees the piece, I want him or her to be able to smell the air, to tell the season within a week or two, and to get a sense of that particular place.

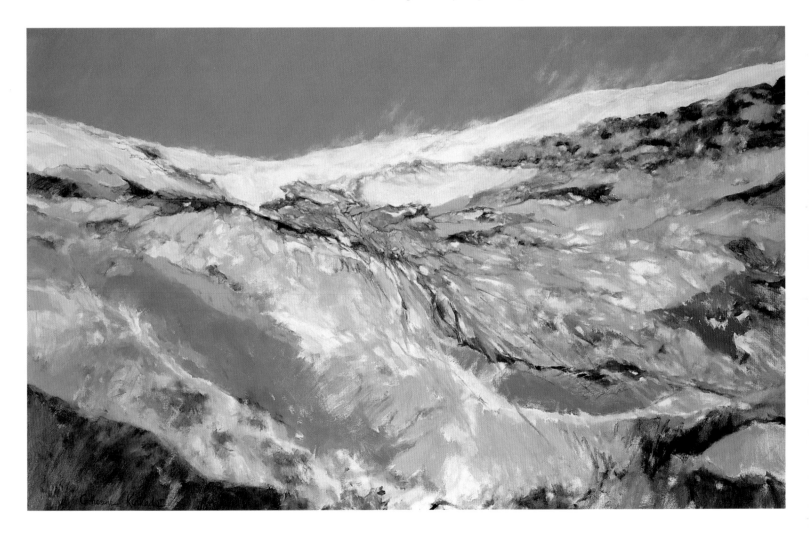

Catherine Kinkade
Summer Marsh I

22 x 28 in. (56 x 71 cm)
Surface: Sandpaper

In this piece, Kinkade was interested in the rhythm of the various vegetation growing on the dune, and how it was moving in the breeze.

I had long been intrigued with using a double light source, with light coming from both sides so that the intensity of color would be almost equal. That's very challenging to paint, I think. It is a light effect favored by the great Swedish painter Anders Zorn.

Everett Raymond Kinstler
Head

16 x 20 in. (41 x 51 cm)
Surface: Crescent illustration board, Green-gray

Kinstler limits his palette to about six pastels: two or three light colors and two or three darks. The rest of the color in this painting, which he completed in an hour-and-a-half sitting, comes from the tone of the board.

I wanted to show the contrast between the very anxious, alert mother cheetah and the innocent cubs. They are unaware of the potential danger around them; one is even managing to take a catnap sitting up. The mother has just heard the roar of an approaching lion and knows that that is one enemy from whom she cannot defend her cubs. A mother cheetah usually tries to hide her cubs from sight, so I've tried to make the environment look like a place the cubs can blend into.

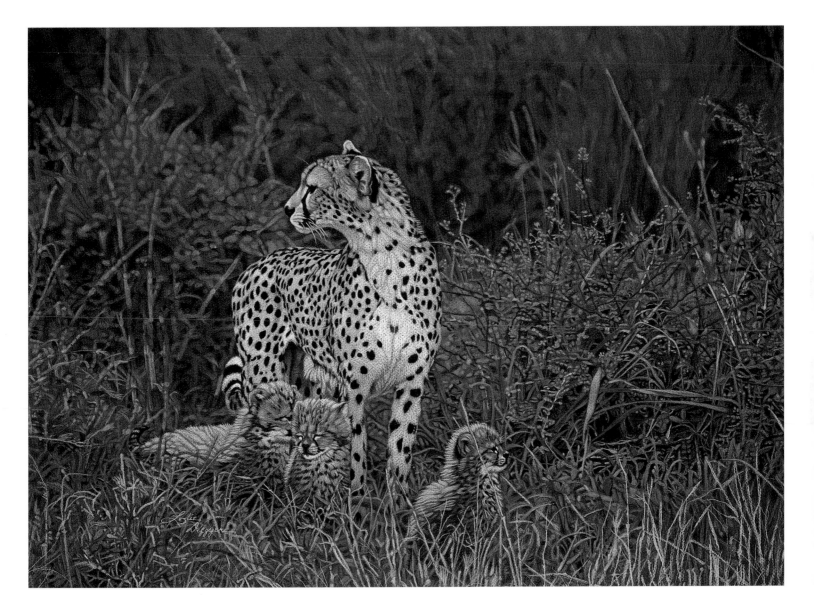

Leslie Delgyer
Catnap

23 x 28 1/2 in. (58 x 72 cm)
Surface: Canson Mi-Tientes pastel paper, Dark green

Delgyer first lays in the background, foreground, and colors of the animals, then blends with cotton swabs. Afterward, she adds colors to certain areas to add interest.

Most of the background in this painting was invented. I used myself as a model, which, considering the pose, was extremely difficult.

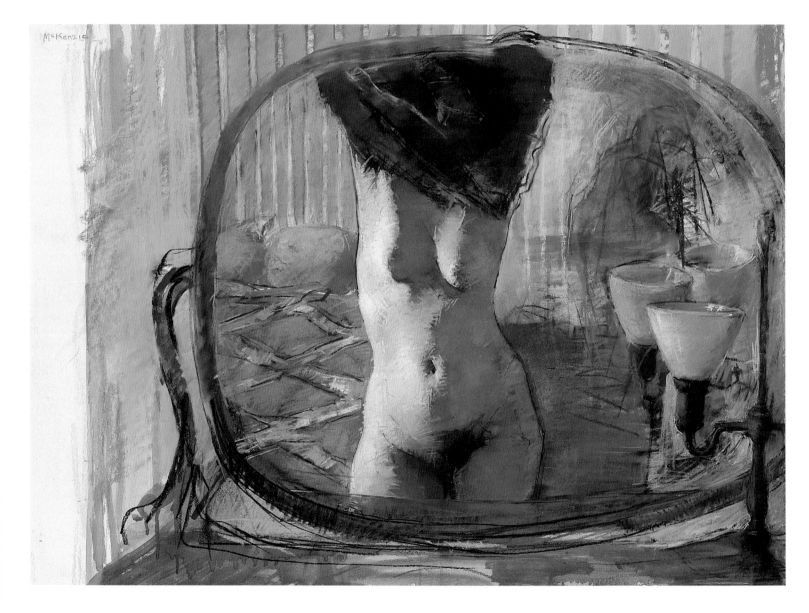

Mary Beth McKenzie
Nude Study

30 x 40 in. (76 x 102 cm)
Surface: 4-ply illustration board

McKenzie likes to first create an underpainting in gouache and then work over that with pastel. In this case, she leaves much of this underpainting exposed.

Atlantic Waves emphasizes the naturally analogous colors of a sunlit ocean scene. Although the crashing waves might lend themselves to a different mood, I attempted to create a sense of peace, where nature and man coexist in synchronicity.

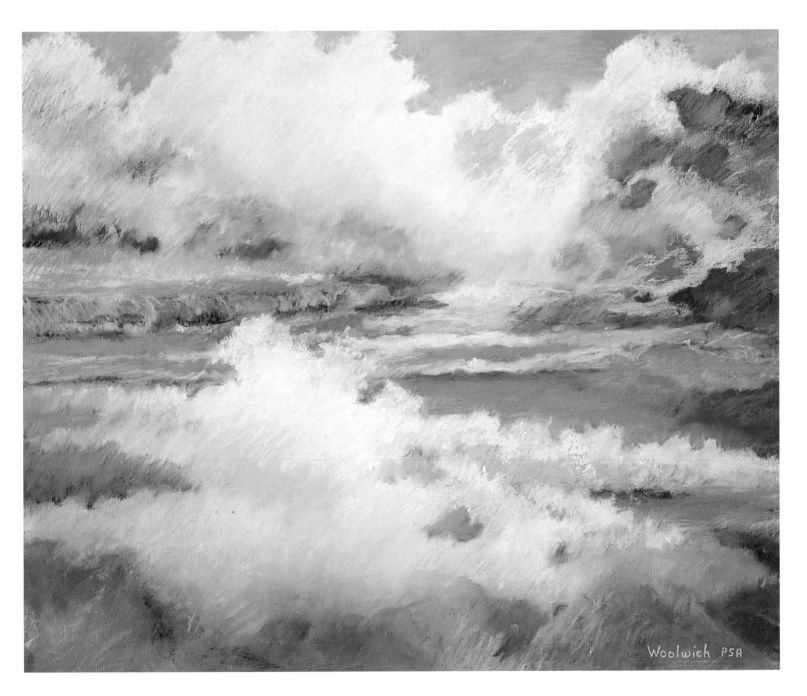

Madlyn-Ann C. Woolwich
Atlantic Waves

22 x 28 in. (56 x 71 cm)
Surface: Handmade pumice board

Woolwich underpaints with cobalt purple and ultramarine acrylic washes to increase the impact of the color in this work. In the final stage, she scumbles to intensify the darks, add density to the lights, and emphasize the focal point.

I love painting San Francisco. In particular, I love the old architecture there. In this painting, I got into the abstract shapes of the lighted windows and the twilight color of the sky and building. There is a moment that happens a little while after sunset when the colors are very rich. It was that moment that I explored in this work.

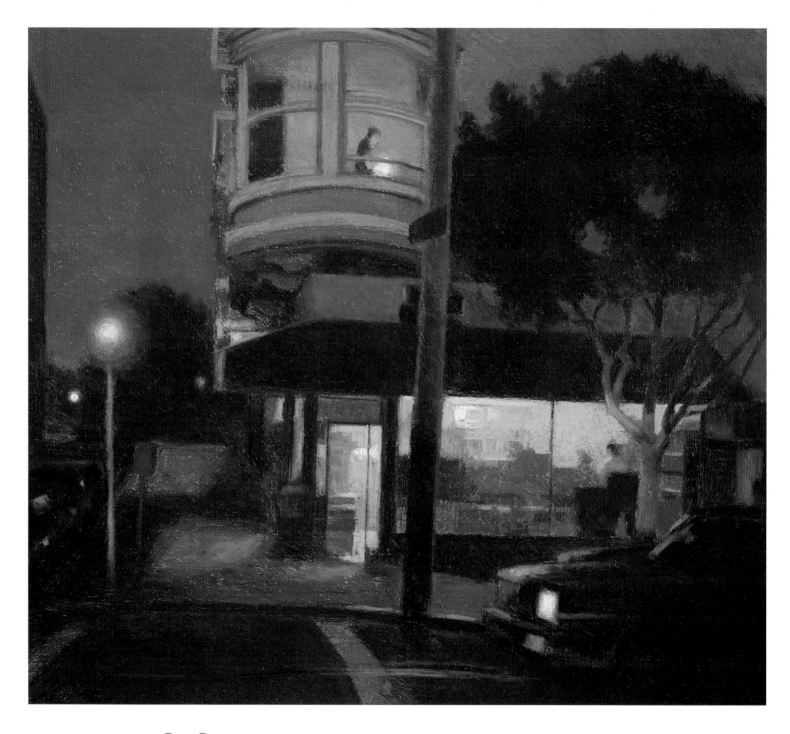

Doug Dawson
The Road to Telegraph Hill

33 x 37 in. (84 x 94 cm)
Surface: Masonite

Dawson starts this painting with three sticks of pastel, each of a different value: dark green, a middle value of red, and a light blue-green.

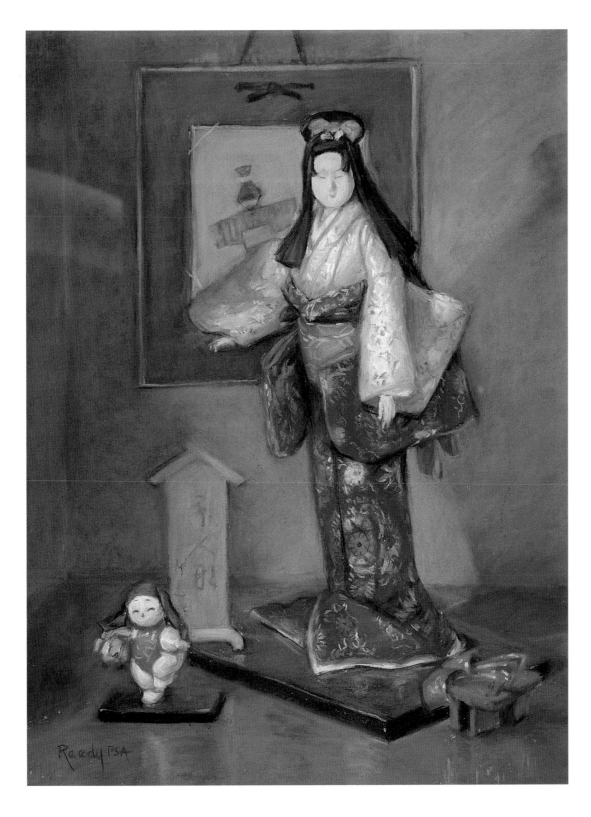

Japanese Doll *is a painting of a type of subject matter I have kept close to my heart as a link to the first twenty years of my life. I wanted to express my love and appreciation for these traditional art objects, which richly nurtured me, especially in recent years, when I made peace with being bicultural. This painting is not only a still life with varied colors, textures, and forms but a symbol that my Japanese heritage and Western art form have harmonized within me.*

Mitsuno Ishii Reedy
Japanese Doll

18 x 14 in. (46 x 36 cm)
Surface: Ersta sanded pastel paper, Buff color

Reedy uses sharpened hard pastels for the fine details and pastel pencils to feather over the areas that need to be softened.

45

I work from models twenty hours a week, and it has allowed me to explore many aspects of the human body. I often find only a small portion of a pose interesting. Here, I chose to do a cropped figure, seeing it very much as an abstract form. The richness of the robe and the sensuousness of the curves of flesh were what interested me the most. By eliminating all other aspects of the pose, I can focus viewers' attention on just those elements.

Mary Close
Red Robe

20 1/2 x 14 1/2 in. (52 x 37 cm)
Surface: Canterbury heavyweight cover stock

Close likes to paint in pastel because she can build up many layers of colors and each will retain its integrity. She blends minimally, however, to keep the hues fresh.

My New York City studio is adjacent to the Union Square Open Market, where there are always displays of fresh and appealing apples in a simple, basic, market environment. The apples seem pure in their cartons, as if nature's bounty has been delivered directly to the market without the intervention of any distractions or impurities whatsoever.

Barbara Fischman
Market Apples

12 x 17 in. (30 x 43 cm)
Surface: Ersta sanded pastel paper

Fischman carefully makes a drawing in which she marks the negative shapes and the position of each apple. To break up the monotony of using a limited palette, she varies tone and manipulates warm and cool colors.

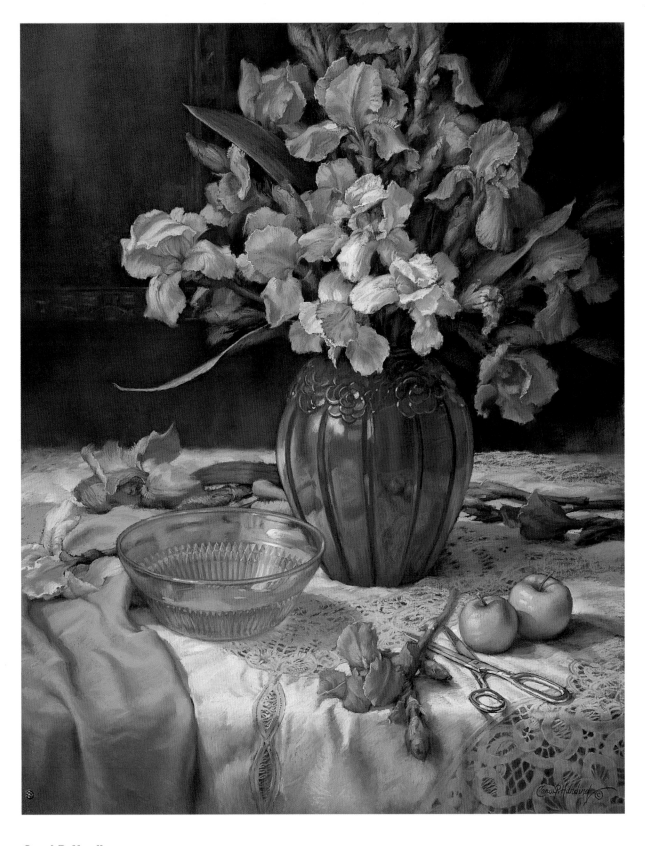

Spring in Utah can be very beautiful, and one of the greatest contributors to that beauty is the irises. I've enjoyed painting them for years. This still life was arranged in my studio with irises from my garden. To me, the iris represents a promise kept, a renewal and celebration of life.

Carol P. Harding
Iris; Pink, Yellow, and Blue

27 1/2 x 22 in. (70 x 56 cm)
Surface: Ersta sanded pastel paper

Harding starts with an underpainting consisting of a transparent stain with a thin wash of turpentine and oil in a warm gray-violet color.

I sketched this vendor on-site in Turkey. Back in my studio, I made individual sketches of the Turks, as I was inspired by their language and culture and the colorful mosques. And from there, I composed this painting.

Juanita G. Farrens
The Vendor

30 x 24 in. (76 x 61 cm)
Surface: Arches 300-lb. watercolor paper

Rather than draw directly, Farrens uses vertical and diagonal strokes to build up her colors and let the image evolve organically. Afterward, she adds curvilinear patterns to further develop the image.

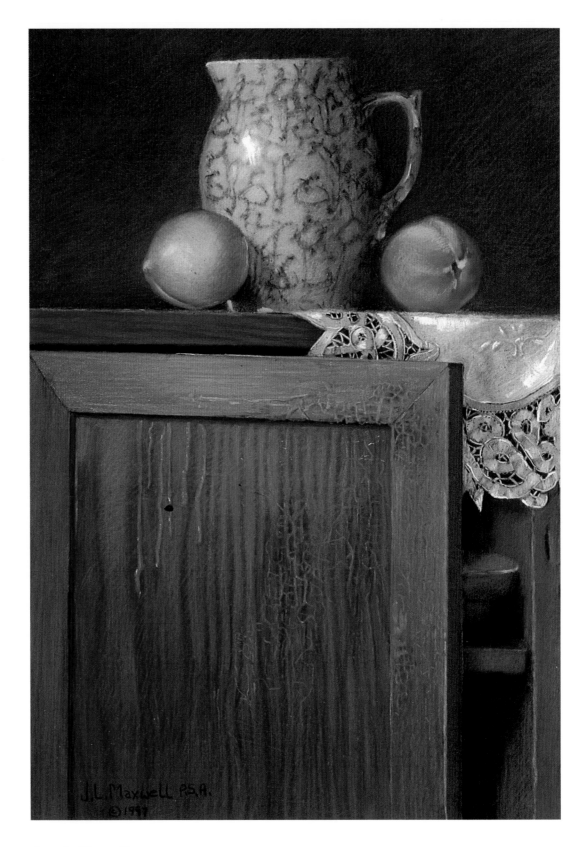

I love the character of old objects and chipped crocks. I have an old hutch filled with wonderful flea-market finds. It is texture and light, however, that reside at the true heart of my paintings, and I use a single light source to help define the texture of my still-life objects. I love the challenge of recording the rough surface of an old pot or cinder block, for example, or the contrast of a piece of cloth against the smooth skin of a pear or a translucent grape.

June L. Maxwell
Sally's Mother's Pitcher

19 1/2 x 14 1/2 in. (50 x 37 cm)
Surface: La Carte pastel paper

Maxwell works from dark to light, blending only with her pastel sticks and allowing color from the layers underneath to show through. She says she knows she's been successful when she can look at her work and feel the texture.

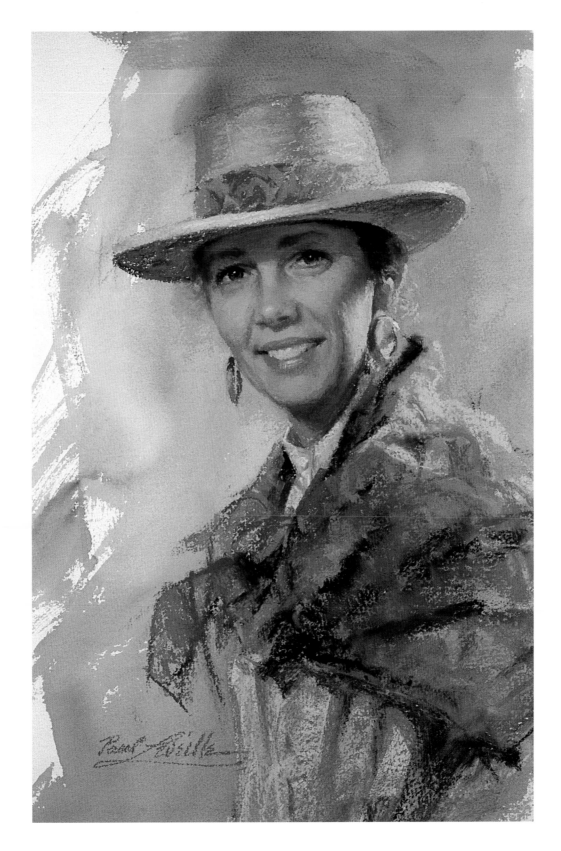

My wife, Pat, wears this hat often in the summer, and the colorful hatband, along with the scarf, inspired me to attempt a portrait using watercolor and pastel together.

Paul Leveille

Pat

20 x 16 in. (51 x 41 cm)
Surface: Arches 300-lb. watercolor paper

After making a drawing of the head in soft vine charcoal, Leveille applies several bold, colorful washes of watercolor over most of the surface. When this dries, he paints in pastel, blending the colors with his fingers as necessary.

The subject matter of my paintings is the northern-California landscape. My work reflects my own way of seeing and responding to nature, and my compositions and use of color reflect my own sense of balance and harmony. The viewer is invited to share a moment of tranquillity.

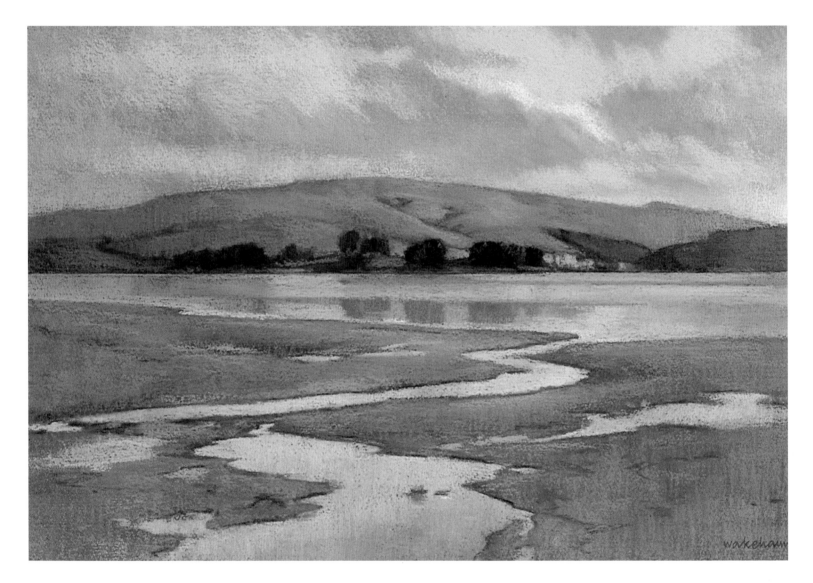

Duane Wakeham
Tomales Bay, Low Tide

19 x 29 in. (48 x 74 cm)
Surface: Arches 300-lb. cold-pressed watercolor paper

Wakeham paints on stretched watercolor paper prepared with two coats of a mixture of gesso and powdered pumice. He tones this surface with an oil-and-turpentine wash, usually of burnt sienna. He then makes an underpainting in hard pastels, which he dissolves with turpentine or a turpentine substitute, and develops the image with soft pastels using hatching and scumbling.

I think of most of my animal paintings largely as figurative works. The animals to me seem to be standing in temporarily for a human being. Delta Pig *is a small still life of a somewhat unnaturalistic pig alone in a somewhat unnaturalistic landscape. I feel more at ease creating a special mood with an animal rather than a human, and that mood, or feeling, is achieved quicker and easier when I work in pastel.* Delta Pig *is all about mood—not pigs.*

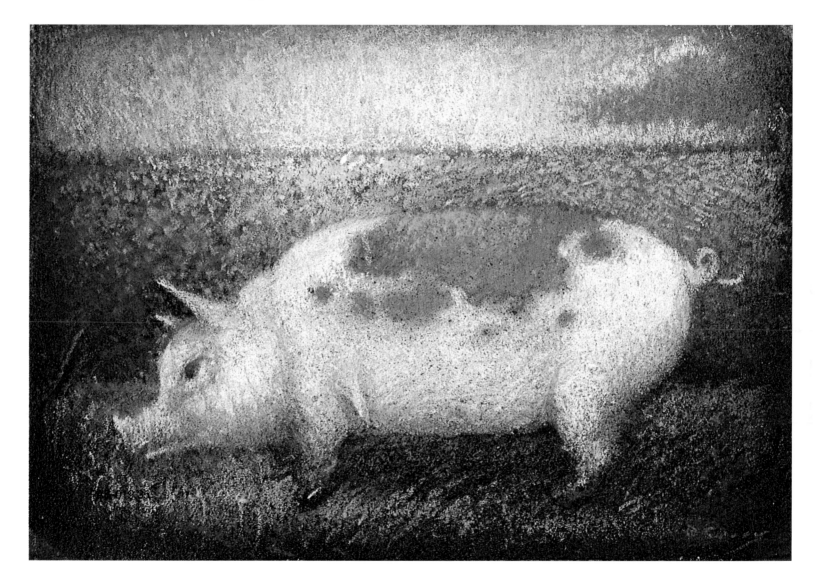

Bill Creevy
Delta Pig

5 x 7 in. (13 x 18 cm)
Surface: Wallis sanded pastel paper

Creevy created this painting using a combination of soft and hard pastels and adding final details in pastel pencil. To darken the color in areas, especially around the edges of the work, he generously applied fixative, darkening the colors with something of an airbrush effect.

The markets and people of the Caribbean Islands are among my favorite subjects. This painting captures the striking pose of a vendor looking for her next customer.

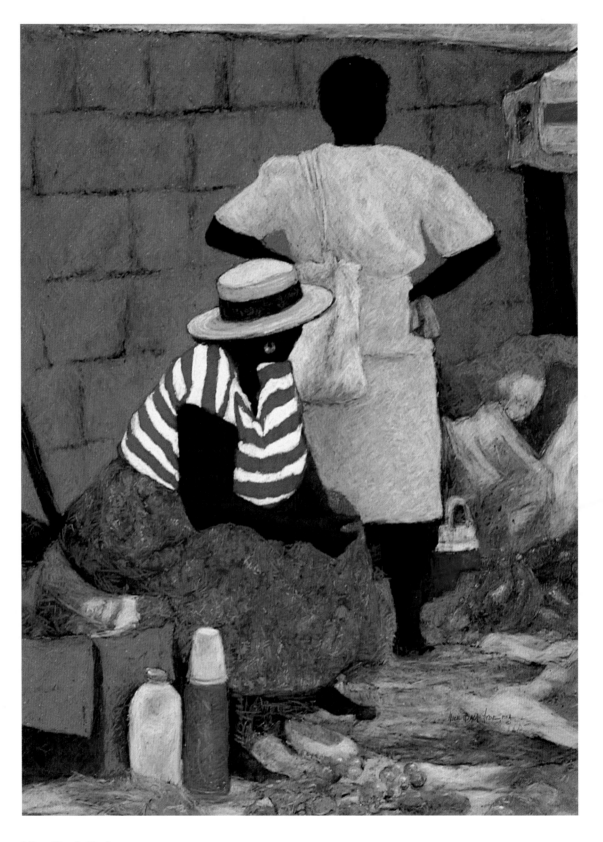

Alice Bach Hyde
Antigua Market Woman

36 x 26 in. (91 x 66 cm)
Surface: Ersta sanded pastel paper

Hyde works from photographs she takes on her trips to the Caribbean. She often combines imagery from many different photographs into one painting, as she did here. She added the woman who is standing to offer a vertical contrast to the horizontal image of the seated woman.

Turnips and red peppers are two of my favorite vegetables—both for eating and painting. They are brilliantly colored and designed and are a delight to paint.

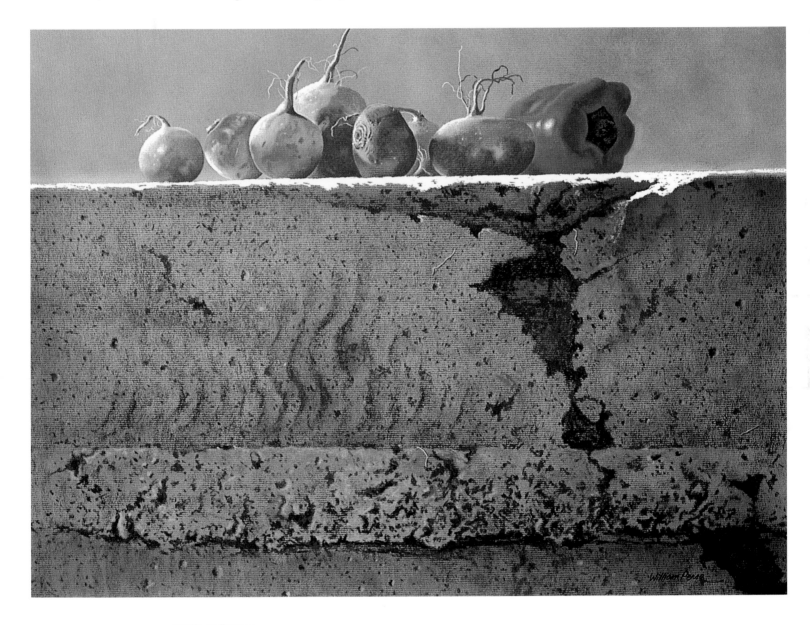

William Persa
Turnips and Pepper

18 x 24 in. (46 x 61 cm)
Surface: Strathmore 500-series paper

For this still life, Persa uses the old, weather-beaten cement wall as the stage and the late-afternoon sun as the spotlight. He keeps the composition simple and uncluttered to convey a sense of silence.

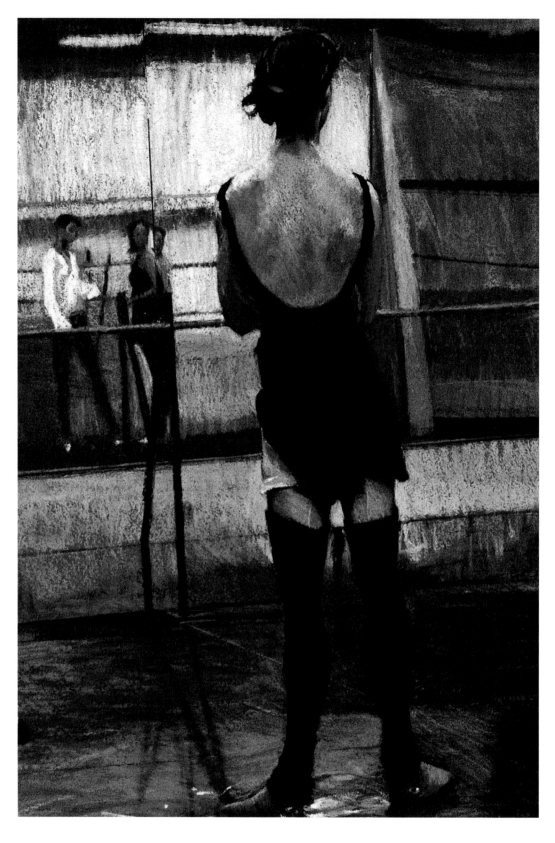

Jenny, the dancer in this painting, walked into the room and I was immediately motivated. The black stockings, or warm-ups, she was wearing gave a sexiness to a simple pose. I aimed to capture the moment.

Rhoda Yanow
Black Stockings

24 1/4 x 18 in. (61.5 x 46 cm)
Surface: La Carte pastel paper

For her figurative work, Yanow prefers to make her initial sketches light so that if the model moves she can easily make adjustments to her work.

The radiant evening light streaming through the window creates the drama and compositional simplicity I was seeking to portray in this fascinating old Bourbon Street bar in New Orleans. I borrowed the old man in this painting from a work I did twenty years ago to enhance the ever-aging character of the setting and to enrich the chiaroscuro lighting.

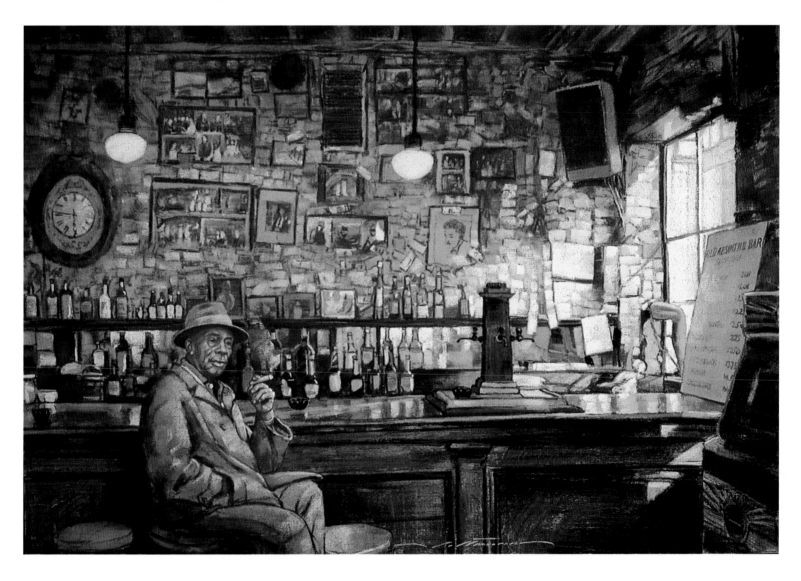

Alan Flattmann
Old Absinthe Bar

28 x 40 in. (71 x 102 cm)
Surface: Polymer panel

Flattmann begins each of his paintings with a strong charcoal drawing, which he sprays with workable fixative. He establishes the color scheme with loose pastel strokes, using the side of the sticks and blending lightly, and then sprays this layer with fixative. He develops the painting with broad pastel strokes to bring out the rough texture of the granular ground.

I have this love of the moods of the marshes. I was painting up in Essex, Massachusetts, which is where I discovered this house. A lot of artists paint in this area. It's the mood and quality of it that attracts us, the subtlety of colors. This house is about 200 years old and was part of the boat-building industry at one time. It's amazing how it has withstood the gales and storms. The whole place has a timelessness to it.

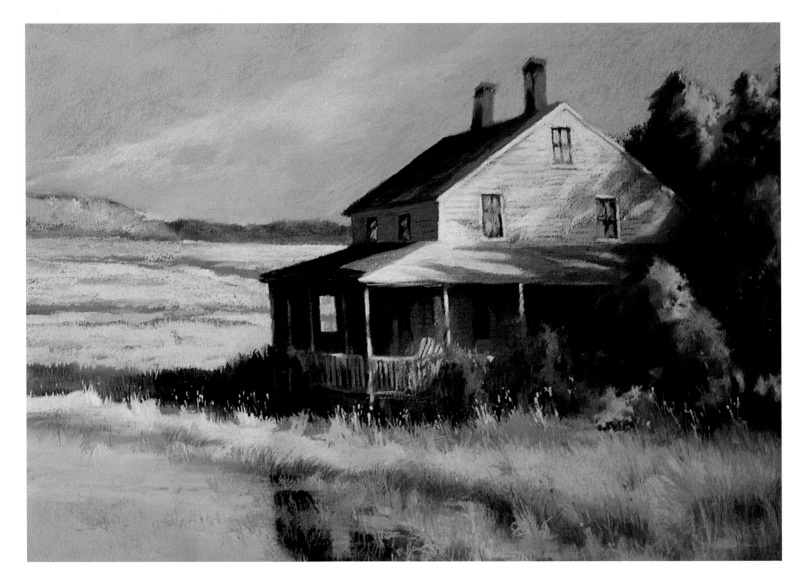

Frank Federico
House on Essex Marsh

30 x 40 in. (76 x 102 cm)
Surface: Bainbridge board

Generally, Federico first applies an underpainting in either gouache, tempera, or acrylics. He favors a pastel palette consisting of high-key colors that lend themselves to vibrant images.

In White Turnip Still Life, *I thought the turnips, dried hydrangeas, and little clay vase all shared a warm, rosy glow that made them seem to belong very much together.*

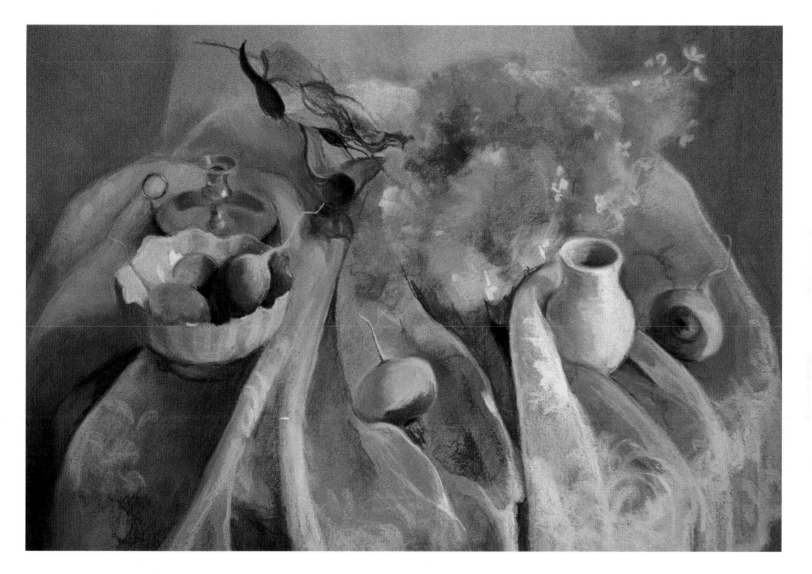

Carol Duerwald
White Turnip Still Life

19 x 25 in. (48 x 64 cm)
Surface: Canson Mi-Tientes pastel paper

When composing a still life, Duerwald enjoys selecting objects that are dissimilar in nature and creating a harmonious painting through the use of light and color.

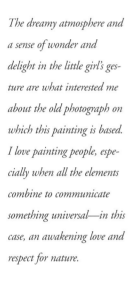
Diane Rosen
Girl with Sheep

28 x 18 in. (71 x 46 cm)
Surface: Fabriano Murillo printmaking and drawing paper, Pearl gray

To give this work a dreamlike quality, Rosen limits her palette to raw and burnt umbers, burnt siennas, yellow ochres, and dark grays, using the full range of values for each color.

Completing Mary *was a matter of trying to capture a very elusive personality. This young lady is a very timid, quiet person, and I feel like I really captured that in her eyes. She had difficulty posing and couldn't look right at me or a specific spot. She was very embarrassed at sitting and went off into a dream world. I had to let her do her own thing—I usually do that with all of my sitters. The most important part of painting a portrait is trying to find the personality. That's the fun of it.*

Thelma Davis
Mary

20 x 16 in. (51 x 41 cm)
Surface: La Carte pastel paper

Davis did her best to work around the model's shyness. She made many quick sketches to arrive at this pose.

Broadway at 17th depicts my city, with all its movement, hustle and bustle, color, and excitement. In painting outdoors, I have gotten used to the sidewalk critics, and I often incorporate them in my painting later on.

Lorrie B. Turner
Broadway at 17th

30 x 38 in. (76 x 97 cm)
Surface: Museum board

Because she often paints on-site, Turner must work quickly to capture the essence of a scene before the lighting changes. Later, in her studio, she refines her paintings.

I was inspired to do this painting instantly after I saw the subject. It was begging to be painted. The contrast of soft folds in the fabric of the sails with the old, textured walls presented a challenge too hard to resist. This is one of my favorite paintings.

Jo-Anne Seberry
Chioggian Sails

20 x 30 in. (51 x 76 cm)
Surface: Crescent hot-pressed watercolor board

Seberry here works with pastels over a watercolor underpainting. She likes the brilliance and translucency of the watercolor and uses it to complement the pastels.

I have found a limitless supply of subject matter right near my home: the county park, a parade on the Fourth of July, the old oak tree on the corner, snow on my neighbors' rooftops. Living in a small suburban town may seem simple—there are no mountain vistas or city excitement, only everyday life. But people and the houses they live in provide me with simple inspiration and have become the focus of my work.

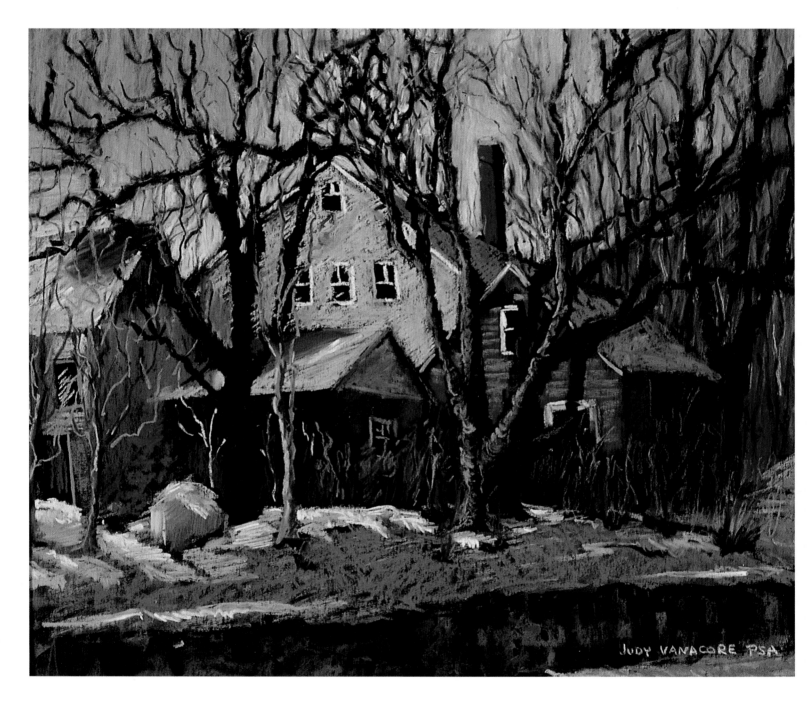

Judith Vanacore
Four Gables

11 x 14 in. (28 x 36 cm)
Surface: Ersta sanded pastel paper

Vanacore first tones her paper with Minwax stain. She then sketches lightly in charcoal and underpaints over this drawing with black or colored inks in the areas that will be darkest in value.

This is the seventh portrait I have done of this subject. I've been researching abstract painting, and have learned to forget about the details of a painting. Even for my portraits, I work in terms of shapes and basically forget the subject. This way there is no filter on how my feelings are expressed in the painting.

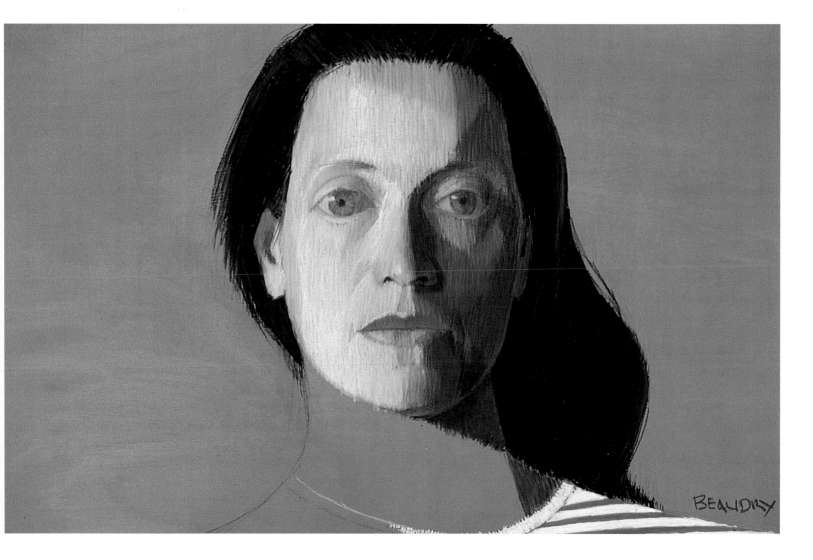

Francois Beaudry
H.L. 7

10 x 16 in. (25 x 41cm)
Surface: Carborundum panel

Rather than concentrate on painting a nose or eyes or a mouth, Beaudry thinks of his portraits in terms of shapes. He assembles the shapes that make up the different features.

There are a few different kinds and colors of daisies growing in my backyard. I find them very interesting as a subject. Plus, they last longer in the still lifes I arrange in my studio. The daisies remind me of an old Chinese saying that the gentlemen of the four seasons are the Chinese blossom, the orchid, the chrysanthemum, and bamboo. Daisies are one of the gentlemen because they are a kind of chrysanthemum.

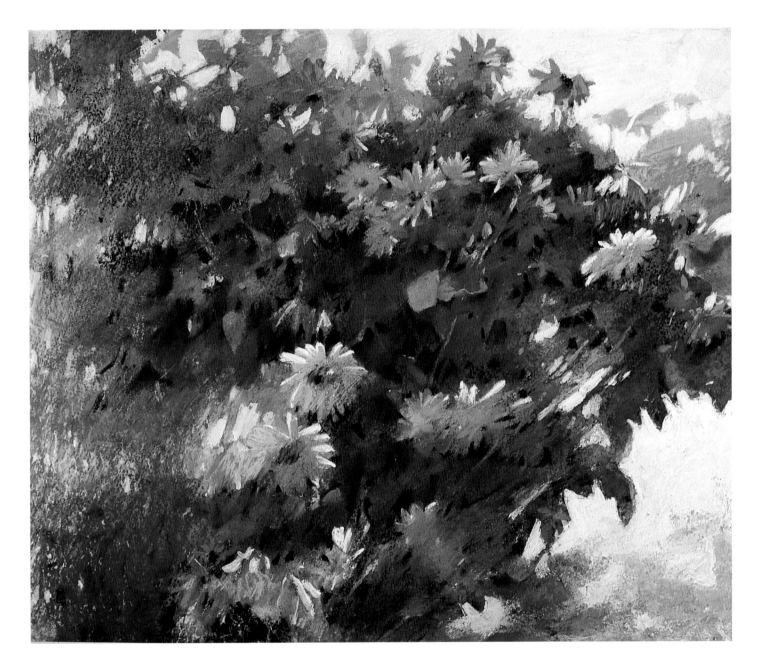

Mei Ki Kam
Backyard Charm

28 x 38 in. (71 x 97 cm)
Surface: Illustration board

Before she starts her painting, Kam makes an outline of her subject in acrylic and marble dust to add texture to the surface. Then she makes a sketch in soft pastels.

I've been fascinated with cicadas. This year I went out early in the night and saw a cicada emerging from its shell. I watched it happen over several hours. It was wonderful to see, especially the way they unfold their huge wings out of that little brown shell. The process is closer to metamorphosis than resurrection, but I think of it as this new life being born.

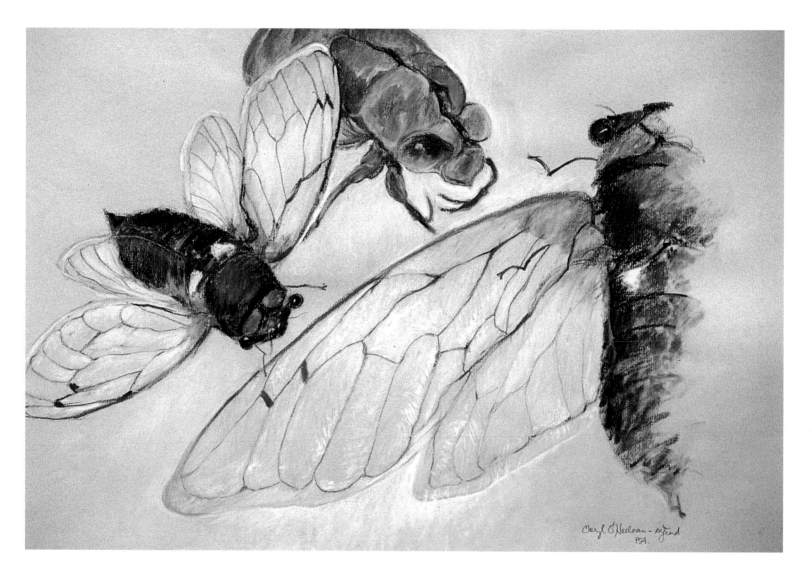

Cheryl O'Halloran McLeod
Resurrection

18 x 23 in. (46 x 58 cm)
Surface: Canson Mi-Tientes pastel paper

For reference material for this painting, McLeod collected cicadas in different stages of development as well as the pods from which they emerge.

This painting is dedicated to all the children who ever spent hours at the beach digging and building in the sand, working so hard at playing, never wanting to go home. The sparkling diamonds and the intense light on the water enhance the magical quality of this group of children. It evokes the nostalgia of all parents who have ever watched their children enjoying a perfect day at the beach.

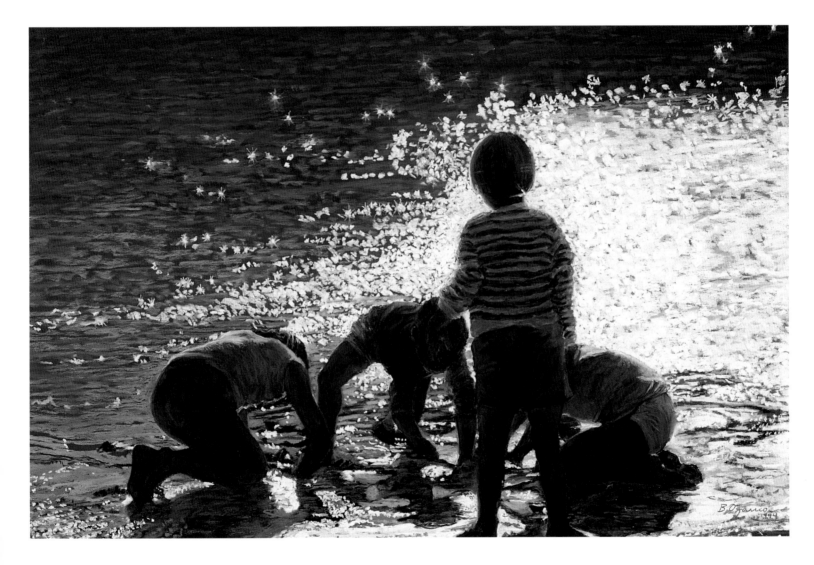

Barbara Ogarrio
In Our Kingdom by the Sea

23 x 32 in. (58 x 81 cm)
Surface: Ersta sanded pastel paper

Ogarrio works on the heaviest sanded papers she can find because she likes to pile on the pastel in big, broad strokes with no blending. She starts her paintings with a charcoal drawing sprayed with fixative but does not use fixative on any of the subsequent layers.

Hopi Pot *was inspired by a trip to Arizona, where I found some of the most beautiful Indian pottery and arti-facts. In this painting I've tried to transform these everyday items into a timeless world by unifying light, color, and form.*

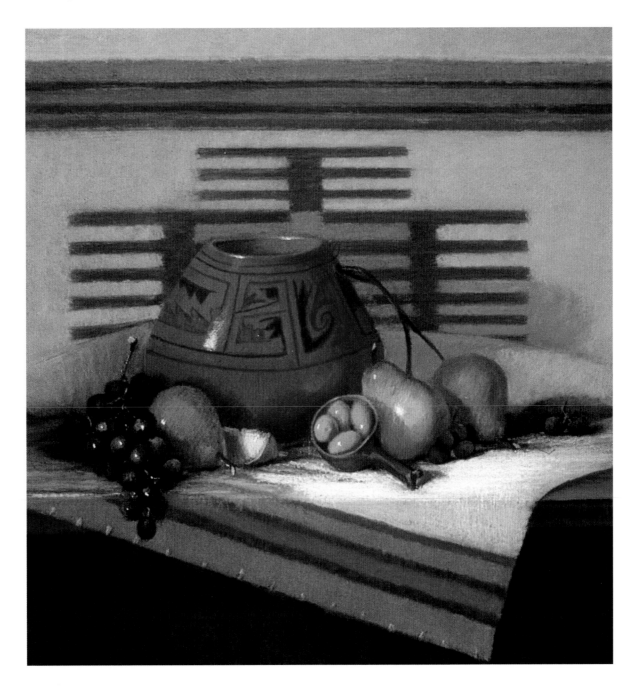

Brenda Tribush
Hopi Pot

22 x 18 in. (56 x 46 cm)
Surface: Museum board

Working on a surface primed with gesso and pumice, Tribush painted layer after layer of soft pastel to create depth and luminosity.

Of late, I have become fascinated with painting figures juxtaposed with the sea. In this case, I had searched for the right scene and the right light, and I eliminated detail to create a bolder composition.

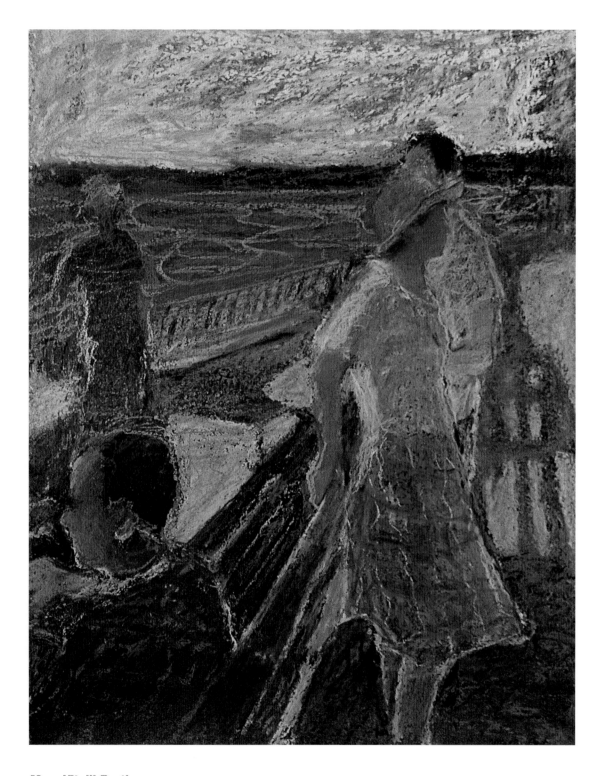

Mary Vitelli Berti
Pier II

26 1/2 x 22 in. (67 x 56 cm)
Surface: Handmade paper

Berti continually reworks the surface of her paintings, sometimes scraping areas away with a razor blade, spraying workable fixative, and then going back into the surface with more pastel in order to create layers of shimmering color.

A view like this one is probably not visible to the naked eye. It's something I composed because I wanted to do a picture of that particular event, and I wanted to do it from a certain point of view. Making it involved having a knowledge of the anatomy of horses and the riders and understanding what they would look like if you saw them from this position. Even though I shift things around from the reference material I use, I want a viewer who has some memory of the event I'm depicting to have a sense of recognition when he or she looks at my painting. People really enjoy a painting that identifies an event but that is filtered through the artist's eye of what the event was like.

Fay Moore
Holy Bull

32 x 44 in. (81 x 112 cm)
Surface: Pastel cloth

Moore composed this painting from many different references, including photographs she took herself, photographs in newspapers and magazines, and her own observations.

These Navajos are part of a family I visit from time to time in Canyon de Chelley, Arizona. I gathered them together, from youngest to oldest, and two of them seemed to be sharing a secret—hence, the title.

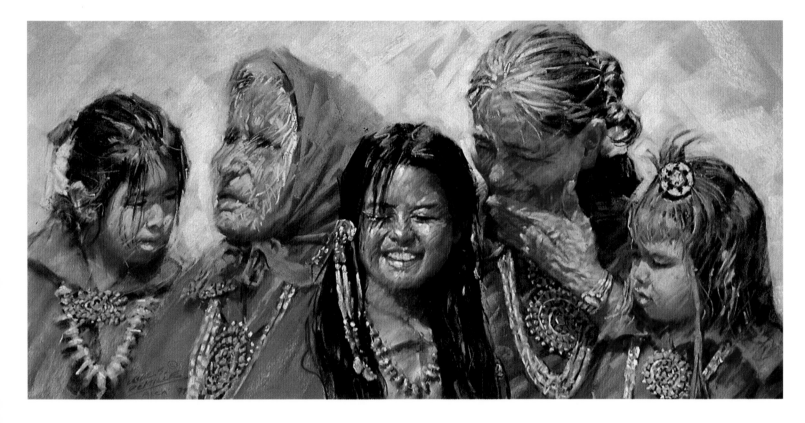

Leslie B. DeMille
Between Us

12 x 24 in. (30 x 61 cm)
Surface: Wallis archival paper

DeMille first paints a watercolor wash and then layers soft pastels over it. For the women's hair, he painted a mass of color with light and shadow, then painted individual strands.

This is a scene that I often pass in Wallen, Tennessee. One particular day, I was struck by the peacefulness of the whole area and decided to paint it.

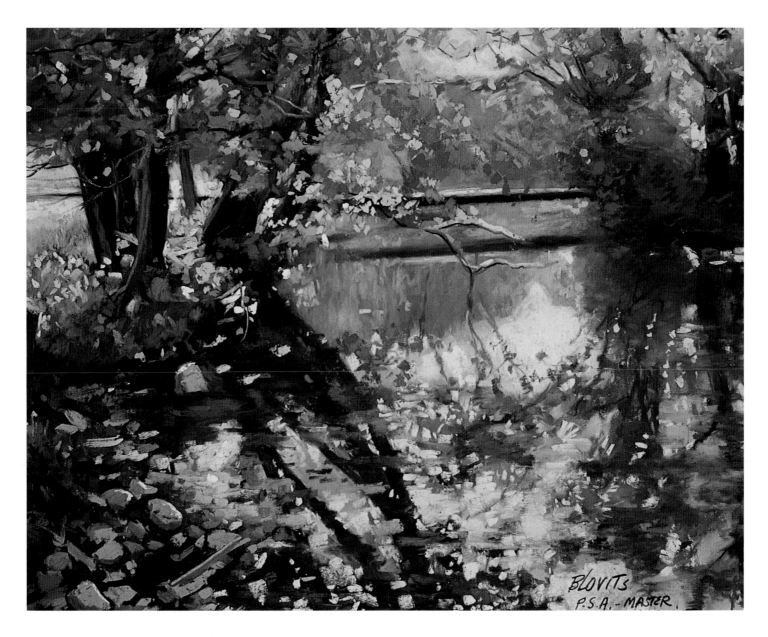

Larry Blovits
Reflections

11 x 13 in. (28 x 33 cm)
Surface: Canson Mi-Tientes pastel paper

To make the reflections in the water appear realistic, Blovits used horizontal strokes, which match those of the water's current, to indicate that the images were on the water's surface.

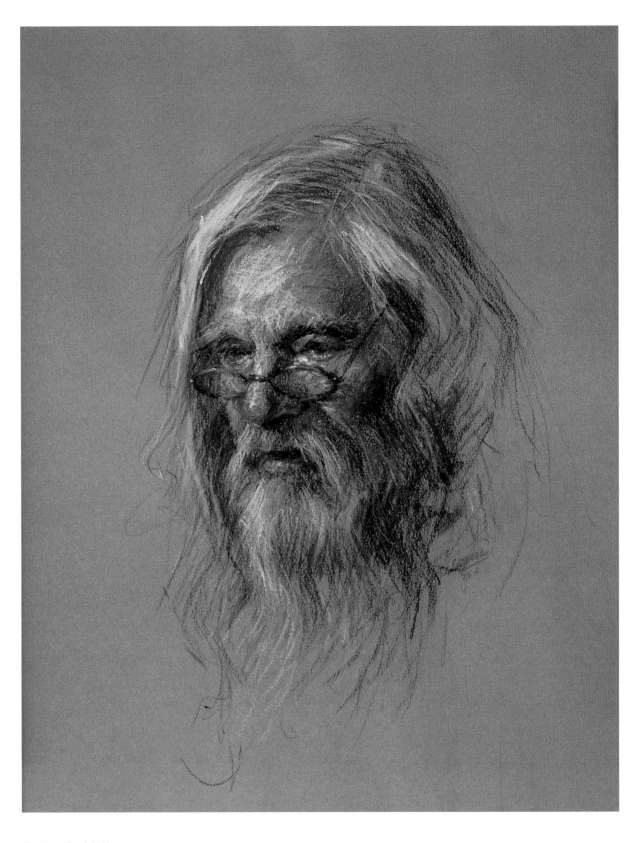

When you're doing a portrait, you have two audiences to please: your client and yourself. The people who commission you have money but are often not sophisticated enough to appreciate portraits that don't look exactly like a photograph. But you have to satisfy yourself and the aesthetes, the people who will look at it as a piece of artwork.

Foster Caddell
Study of Jacob

17 x 14 in. (43 x 36 cm)
Surface: Canson Mi-Tientes pastel paper, Bisque

Caddell works in what he calls a modified impressionistic way. He builds up the painting with smaller and smaller spots of color so that, from a distance, a viewer has a sense of it being a refined image but up close can see that the painting is actually very impressionistic.

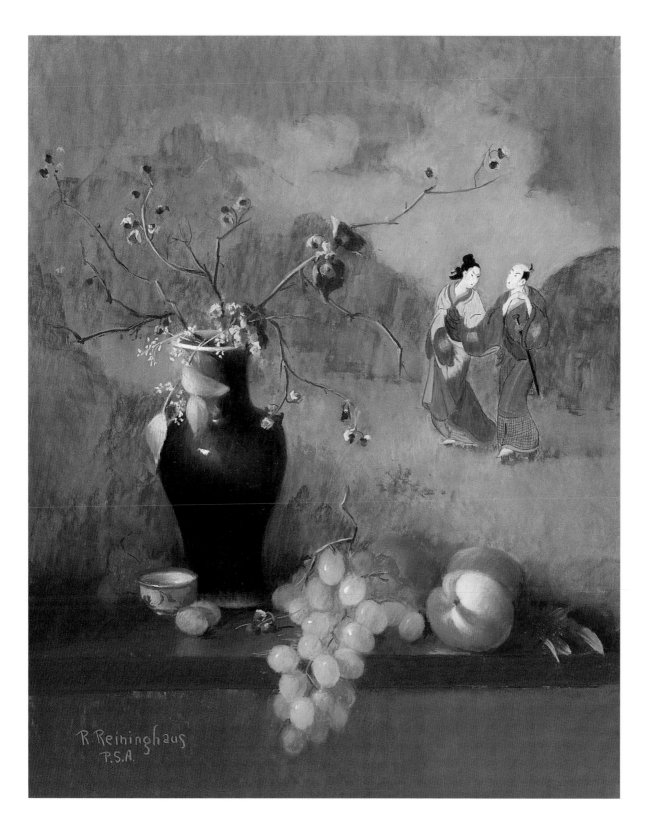

Ruth Reininghaus
Kangxi Vase and Fruit

20 x 16 in. (51 x 41 cm)
Surface: German sandpaper

Reininghaus believes an interesting background can enhance a still life and result in what she calls a double painting. The arrangement of objects in the foreground leads the eye to the second composition in the background.

This woman was modeling for a small drawing group I was part of at the time. I wasn't intending to make a full painting, but when I completed my study of her it suggested a whole mood and feeling for me. So I left it to my imagination and created the environment she sits in and the lighting and feeling of mystery.

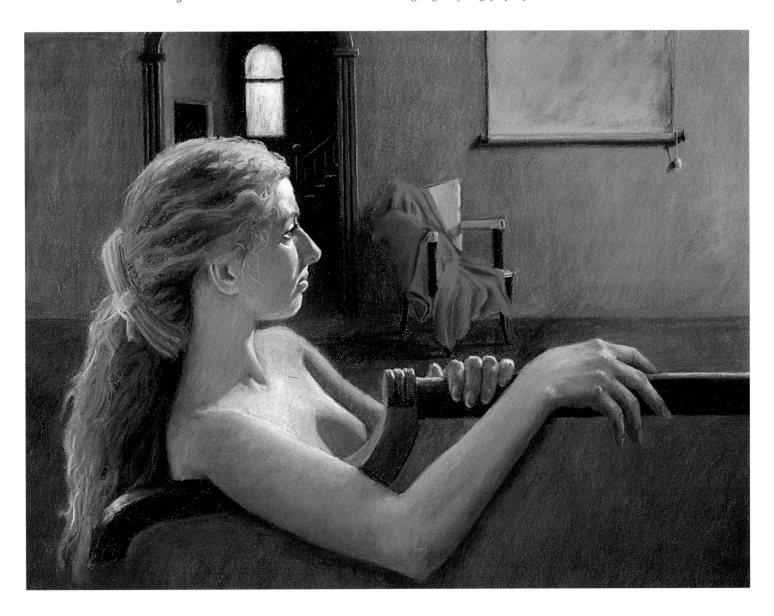

Peter Seltzer
Vigil

19 x 25 in. (48 x 64 cm)
Surface: Canson Mi-Tientes pastel paper

Seltzer has worked a great deal from life, giving him an understanding of the interaction of light and forms. He calls on these skills when he paints from his imagination in his studio.

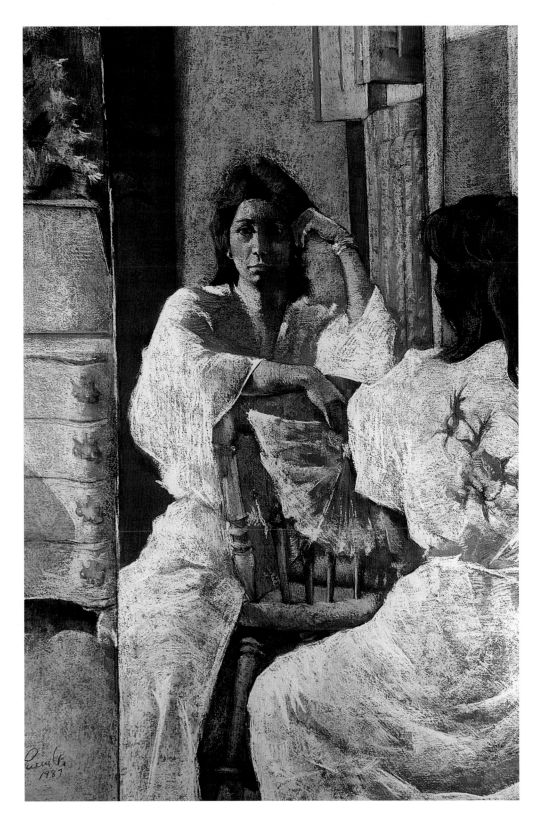

This is an intimate painting of my wife Phyllis done several years ago. Having her seated at the mirror enabled me to get both front and back views. I worked the roundness of the figure against the flat, almost abstract shapes of the room, creating a subtle sense of tension. At the time that I was working on this pastel, a loved-one had died, which is apparent in Phyllis' intense facial expression.

Alexander C. Piccirillo
Entre-Nous

47 x 40 in. (119 x 102 cm)
Surface: Luan plywood

The artist primes the plywood with several coats of a mixture of gesso, water, and ground pumice. He uses a wash of blue-gray acrylic paint as a ground and begins drawing large, broad shapes in charcoal, using a kneadable eraser to pull out the lightest areas.

This is the first painting I ever did where the title came to me before I started the piece. I heard the term "throwaway" being used on TV. I was intrigued by it because before that, I had only heard the term "run-away." I thought it might make an interesting painting. By placing the figure in the center with lots of space around him, I am trying to convey his loneliness and isolation. I placed a sleeping bag over him to show that he was living on the streets. It also made a nice design. Lastly, I added a few empty food cans on the ground to show how he was living.

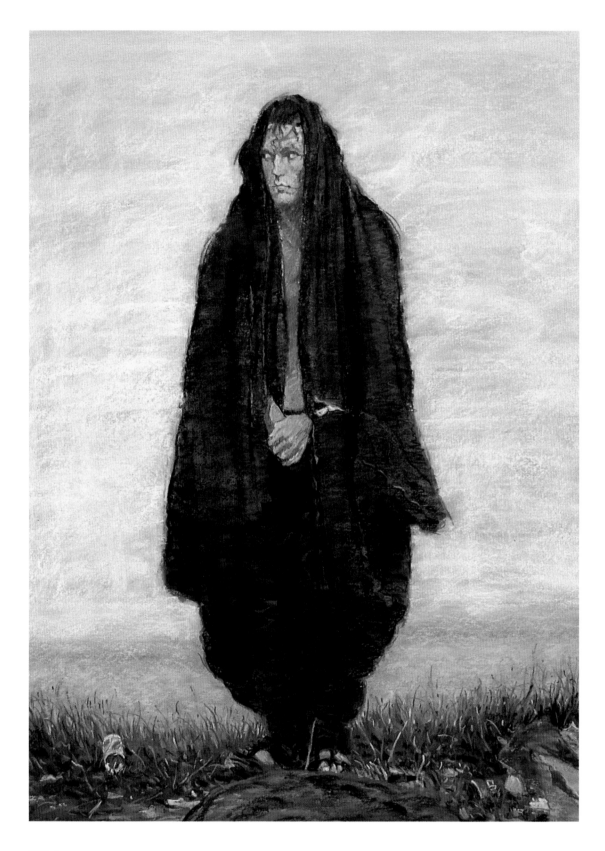

Bill James
The Throwaway

33 x 25 in. (84 x 64 cm)
Surface: Hahnemuhle watercolor board

To give the painting more of a sad and lonely feeling, James uses a somber monochromatic palette. He paints impressionistically, using a loose, color-separated technique. He also glazes one color over another in certain passages.

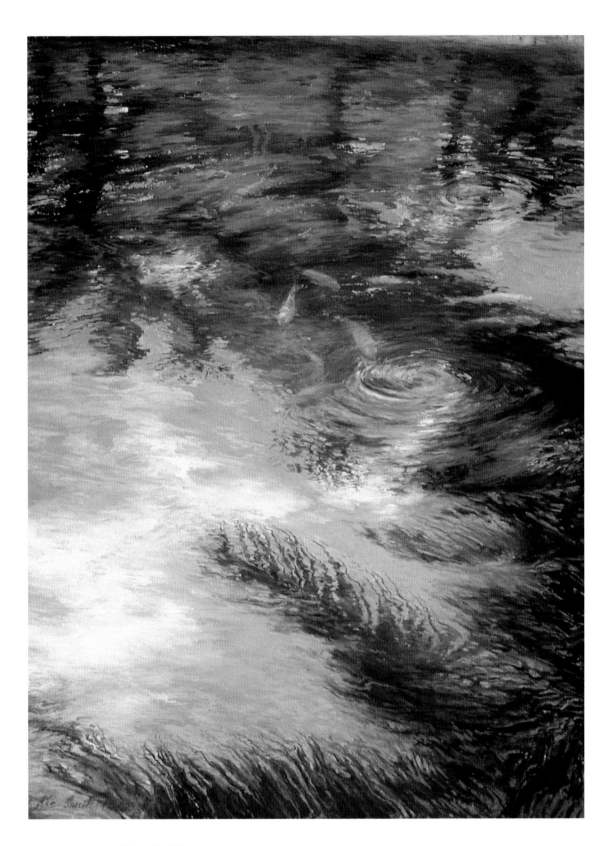

I was doing very abstract works until I moved to North Salem, New York, where the beauty of nature really took possession of me. Everywhere I looked, I saw a painting! I have done a series of goldfish-pond paintings because I am fascinated by the moving fish and the patterns they create in the water.

Rae Smith
On Goldfish Pond IX

27 x 21 in. (69 x 53 cm)
Surface: Ersta sanded pastel paper

Initially, Smith lays in colors that are brighter than those that will appear in the finished piece. This way, she can let them show through in areas to add sparkle to the painting.

79

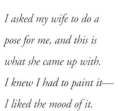

I asked my wife to do a pose for me, and this is what she came up with. I knew I had to paint it— I liked the mood of it.

Joe Hing Lowe
Yoga Pose

24 x 18 in. (61x46 cm)
Surface: Canson Mi-Tientes pastel paper

Lowe's wife posed for this painting, assuming an extremely difficult yoga pose. Lowe had to work quickly to capture it on paper.

My inspiration comes predominantly from sunlight. If it's a gray day, I'm not interested in painting it. I like the way the light moves and changes, particularly in the first and last hours of the day. That's when it's most dramatic but also spiritually moving. I don't feel comfortable painting directly about God, so I do it indirectly through painting about nature. Nature is a stunning testimony of what underlies it.

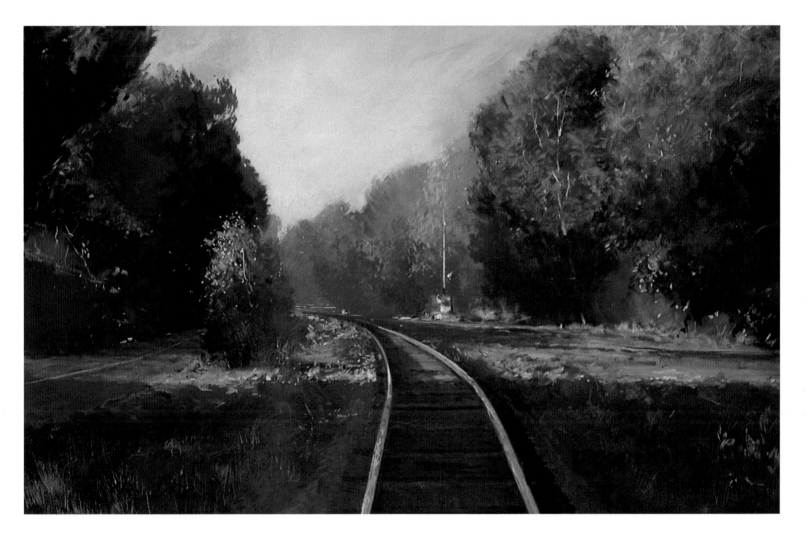

Gil Dellinger
Tracks Through Morada

20 x 34 in. (51 x 86 cm)
Surface: Wallis archival pastel paper

Space and mood are Dellinger's primary considerations when he paints en plein air. He first lays in the colors for the sunlight and shadows, not just because they change so fast but also because he is responding to what he is seeing and is trying to get the feeling of that instant.

Psychological portraiture interests me greatly, so I use a variety of techniques and elements to create emotional depth. Here, I used the model's necklace to bring attention to her face. I added the Monet painting in the background to reinforce the colors.

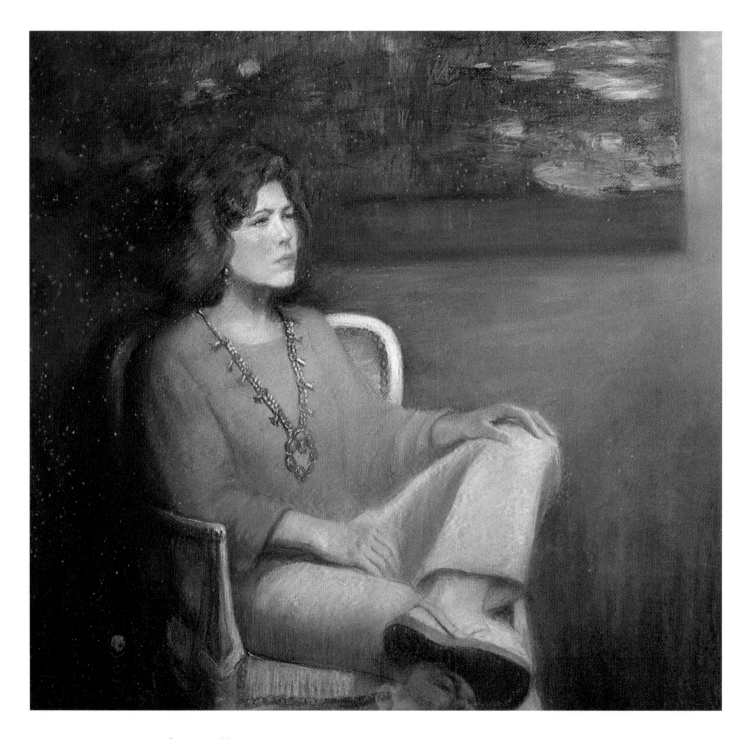

Suzanne Young
Squash Blossom Necklace

24 x 30 in. (61 x 76 cm)
Surface: Canson board

The colors in the model's clothing were disparate, so Young pushed the colors in her painting toward the cool hues, which also brought out the model's red hair.

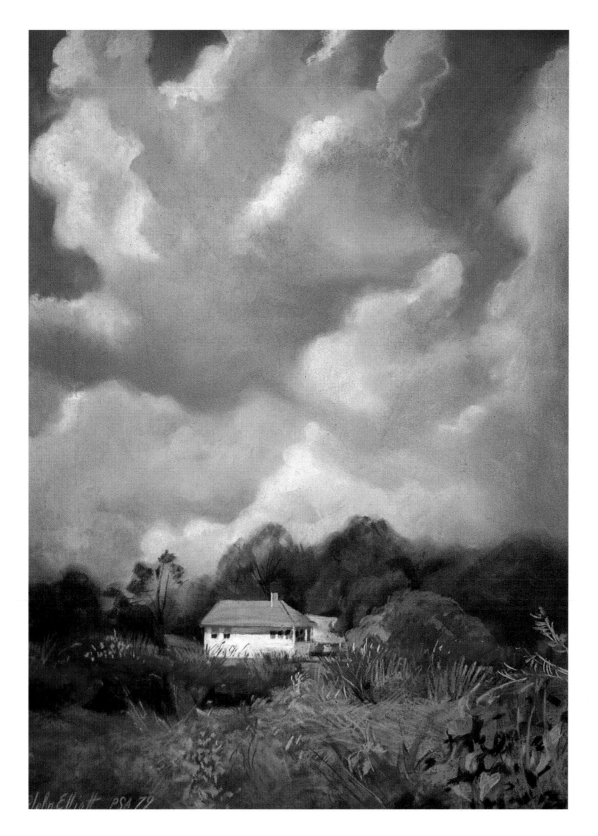

I love to walk in the fields, especially when the sky is staging a spectacular show. I always travel with my pastels, and on this trip, I was rewarded with great colors and wonderful clouds to paint.

John T. Elliot
Country Walk

28 x 22 in. (71 x 56 cm)
Surface: Canson Mi-Tientes pastel paper, Light blue

Elliot often works with water-soluble pastels to create washes, as opposed to using traditional watermedia, such as gouache or watercolor.

I went to Jerusalem and visited the Holocaust Museum. I saw horrible things there. There was a huge photograph—the size of a whole wall—of a street in Krakow, Poland. There were people walking on the sidewalk; they were nicely dressed. There was one old Jewish man with a big beard who was forced to clean the street with a toothbrush. This image affected me so much. I later came across a rabbi who reminded me of the man in that photo, and I made two quick sketches of him. I figured that when I got home, I would make a painting—but not just a portrait: I wanted to portray the rabbi studying the Bible, like a scientist or a scholar.

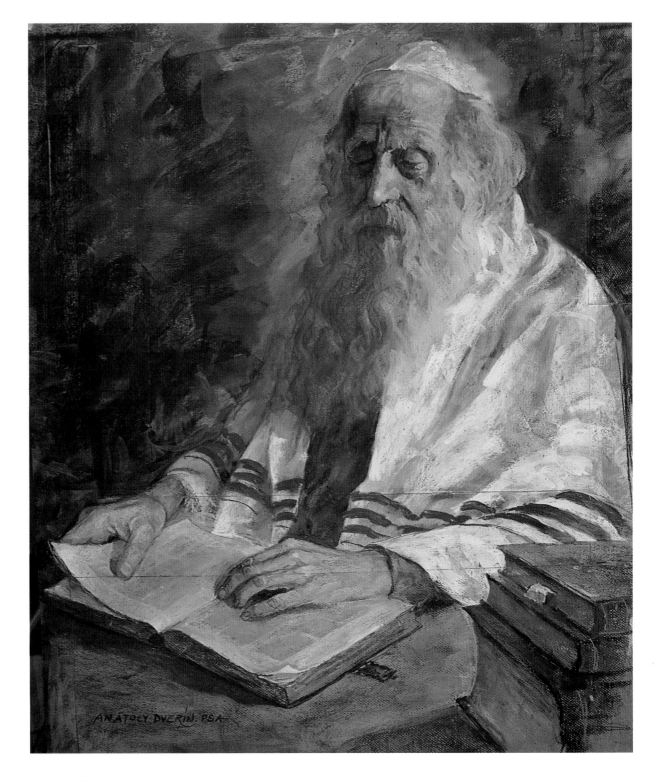

Anatoly Dverin
Rabbi

30 x 25 in. (76 x 64 cm)
Surface: Canson Mi-Tientes pastel paper

Dverin applied the pastels in wide strokes to give the work a painterly look, which he thought was best suited to the subject.

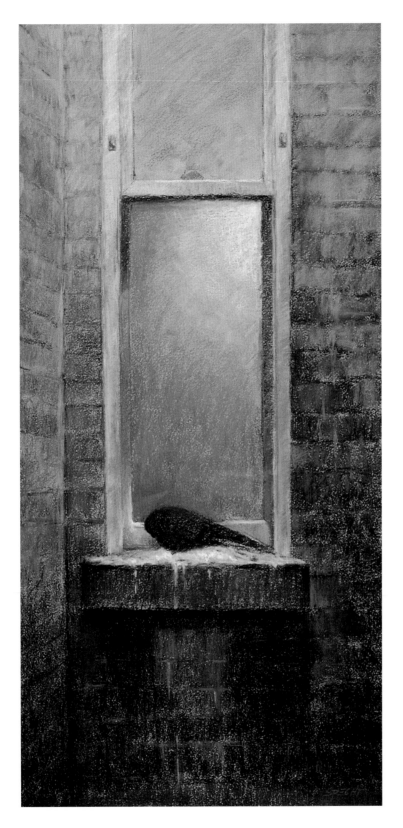

I witnessed this scene many times in the early-morning hours of winter. It symbolized the isolation that can be experienced in the heart of a vibrant and bustling city. The warmth of the light in the window was of little comfort to the lonely occupant, who would soon leave to find his nourishment in the streets, or perhaps from a Good Samaritan.

Lisa Specht
Blue Window—Single-Room Occupancy

28 1/2 x 13 1/2 in. (72 x 34 cm)
Surface: Canson Mi-Tientes pastel paper

Specht had planned this work to be a larger painting with a brick-wall background, but after she did a preliminary drawing in black and white, she decided she didn't need the brick structure. She experimented with eliminating elements of the painting and eventually settled on a double-square format.

85

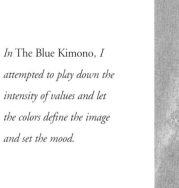

In The Blue Kimono, *I attempted to play down the intensity of values and let the colors define the image and set the mood.*

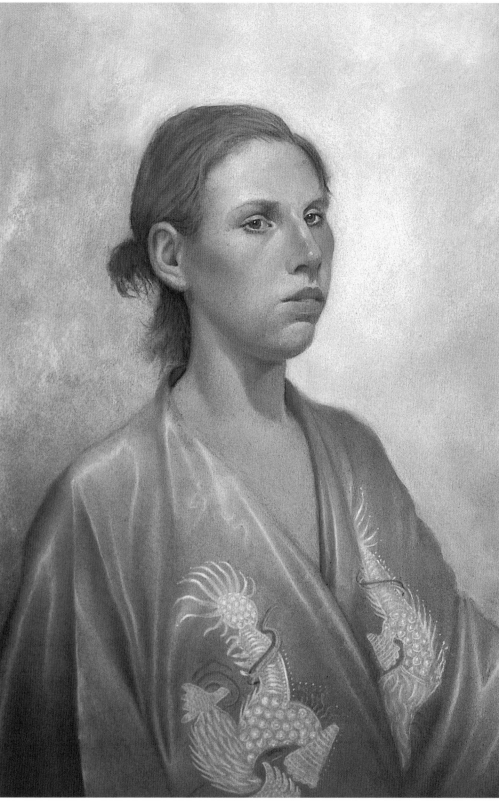

Patrick D. Milbourn
The Blue Kimono

24 x 12 in. (61 x 30 cm)
Surface: Canson Mi-Tientes pastel paper

In this painting, Milbourn applies a muted, multicolored but neutral background in an overall warm-gray tone before carefully drawing in the shapes. He uses soft pastel pencils for the details.

This painting is one of a number of irregular (an allusion to clothing sold with imperfections) works. These paintings display tensions between a naturalism that aspires to the idea of a picture being a window to the world and a technique of distressing that calls attention to the image's two-dimensional support. This painting also suggests the notion that the likenesses of fruits and vegetables persist far beyond their very models. The basket rests on a copy of Matisse's book, Jazz, implying that some art lasts longer than its creator's life.

Jonathan Bumas
Irregular Still Life (Nature Morte)

31 x 47 in. (79 x 119 cm)
Surface: Fabriano/Roma paper

To create sharp, defining edges in the objects he's depicting, Bumas places layers of three-millimeter mylar, which is frosted on one side, on top of the paper. This painting was carefully sabotaged, he says, with stones to create the deckled edges and holes.

I met this magnificent lady and felt as if I had to draw her picture. Her strong features were wonderful. She wore primal colors—not primary but primal—bright purples and blue-greens, which melded beautifully with her tawny skin. The shapes were most fascinating: big earrings, lace, patterned material. As quickly as I possibly could, I put down those shapes. I got myself into a nice artistic frenzy. She's a beautiful woman, and she sat patiently despite how hot it was that day. Everything about her made me want to be the artist to do her portrait.

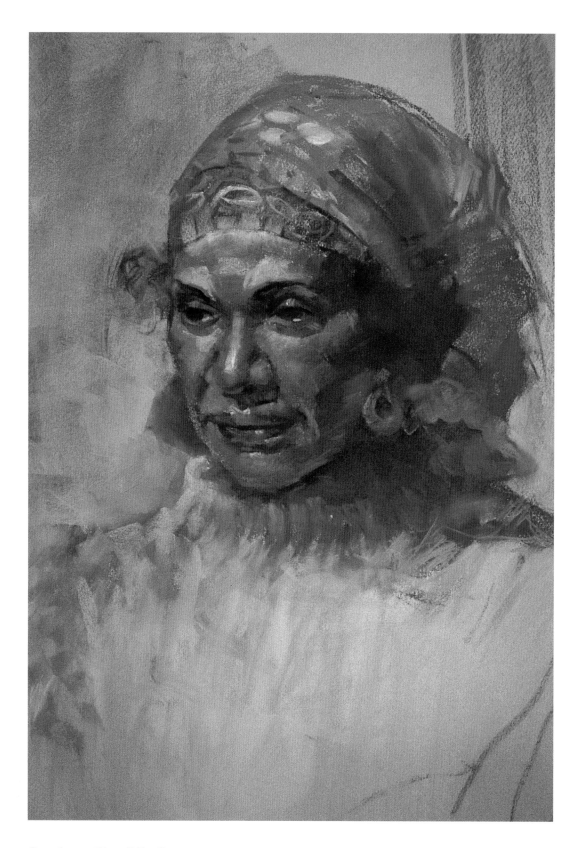

Constance Flavell Pratt
Dorothy

21 x 18 in. (53 x 46 cm)
Surface: Canson Mi-Tientes pastel paper, Sand color

Pratt made this work in a painting demonstration. Because she was under pressure to finish within the two-hour workshop, she aimed to record the strong darks and lights in order to express her subject's well-defined features.

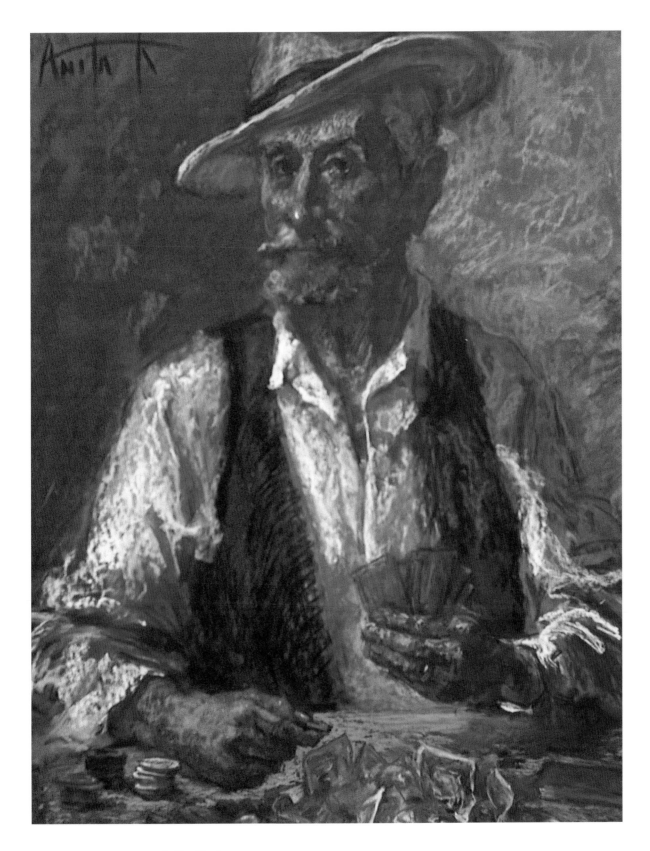

When I met the model for this painting, I knew instantly he would be an interesting character to portray. While deciding what the pose would be, I asked him what he liked to do best, to which he replied, "Play poker." We set up the green card table with the poker chips, cards, etc., and I asked him to give me his poker expression. Since I encourage my models to talk during sittings, I learned a great deal about the game of poker. It was important to emphasize the eyes, which can give away the poker player's hand.

Anita Kertzer
I Call

30 x 24 in. (76 x 61 cm)
Surface: Sanded pastel board, Cream color

Kertzer uses vigorous, overlapping strokes of broken color because she feels they best describe the character and feeling of this image.

The title of this painting suggests several things. The veil is a metaphor for the shadow moving in from the left, swallowing up the remaining light of a crisp, fall day. It is glorious when nature displays her most intense color palette. However, we know this beauty is transient and fragile. Could the shadow then be the coming of winter, looking over us like a frigid veil?

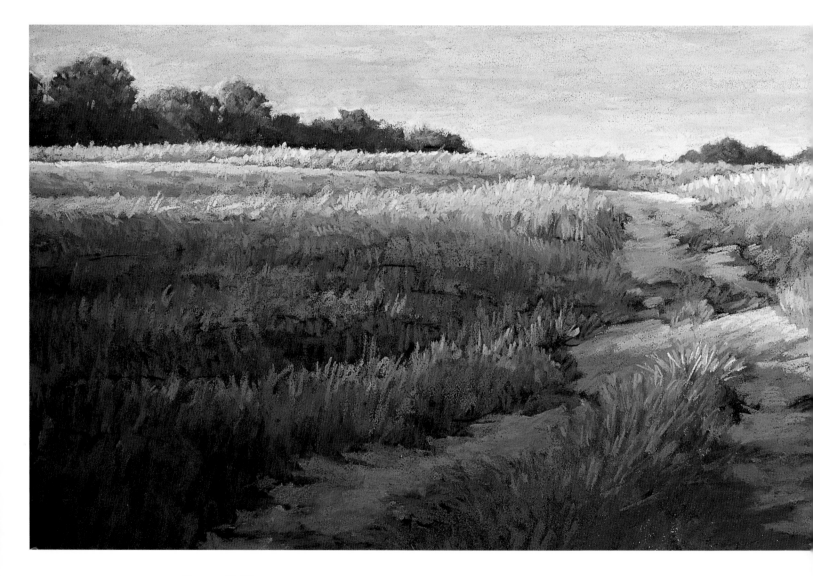

Donna Neithammer
The Veil

19 x 28 in. (48 x 71 cm)
Surface: Canson Mi-Tientes pastel paper

Neithammer begins her paintings with a full tonal study in charcoal. She likes to apply the pastels liberally, resulting in a heavy layer of pigment that often makes the work look as if it had been painted in oil.

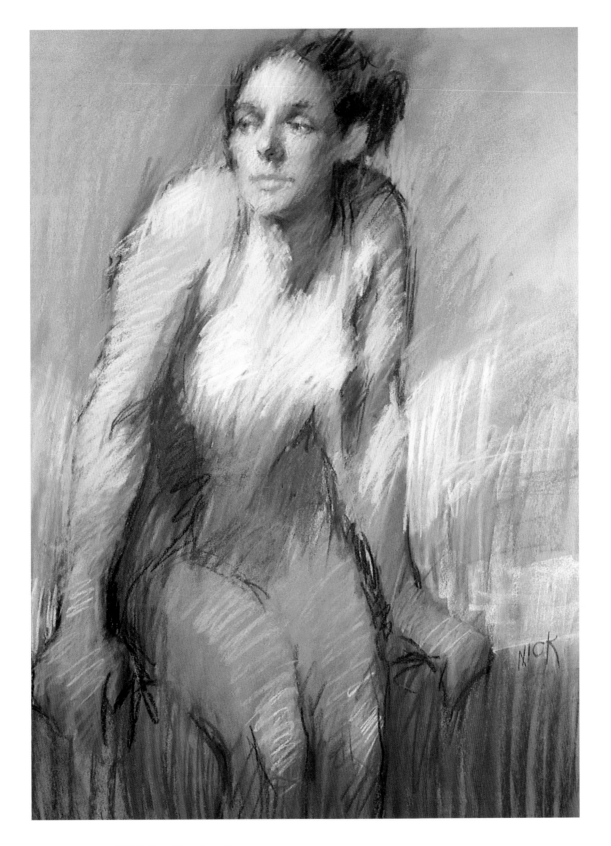

Nicholas Sacripante
Cindy

30 x 24 in. (76 x 61 cm)
Surface: Canson Mi-Tientes pastel paper

Sacripante made this painting during a three-hour drawing session. Although the model was nude, he
chose to paint her clothed.

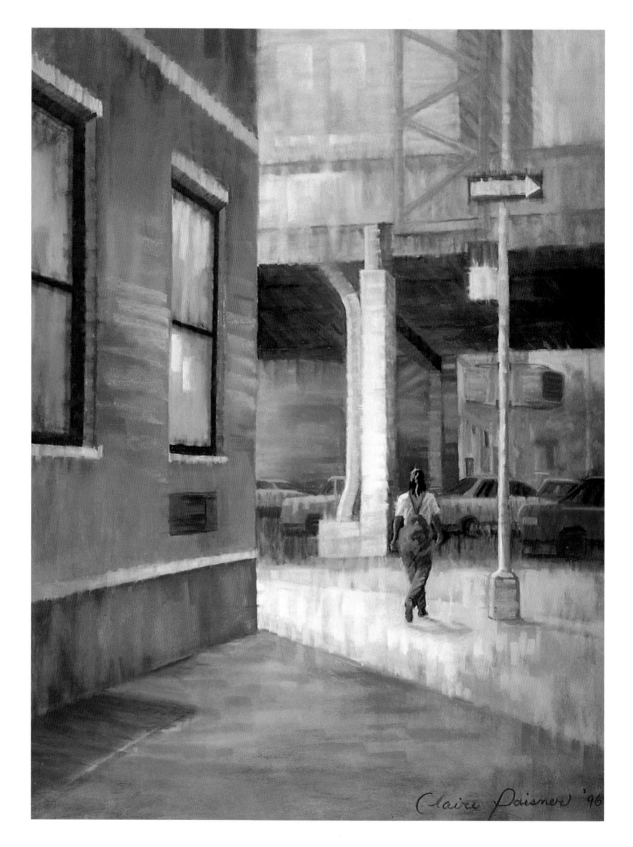

This scene represents Washington Square in lower Manhattan. I say represents because none of my paintings are completely literal, since I move buildings and change colors to improve the overall design while trying to capture the location's essence. Here, I wanted to convey an urban landscape with warmth and activity through the red buildings and lush foliage and the spring in the woman's walk.

Claire Paisner
Girl with a Backpack

25 x 19 in. (64 x 48 cm)
Surface: La Carte sanded pastel board, Antique white

Paisner captures this scene's intense value contrasts caused by the midday sun by painting with a kaleidoscope of colors in both the shadow and light areas. She rendered the figure relatively small to emphasize the overpowering architecture.

Visiting the markets of Guanajuato, I was struck by the brilliant color of the women's costumes, as well as the pyramidal structure of the group of women. Simplicity of line was another attractive element, one I wished to emphasize. I have always been intrigued by ethnic differences among people. I have great respect and affection for Mexican people.

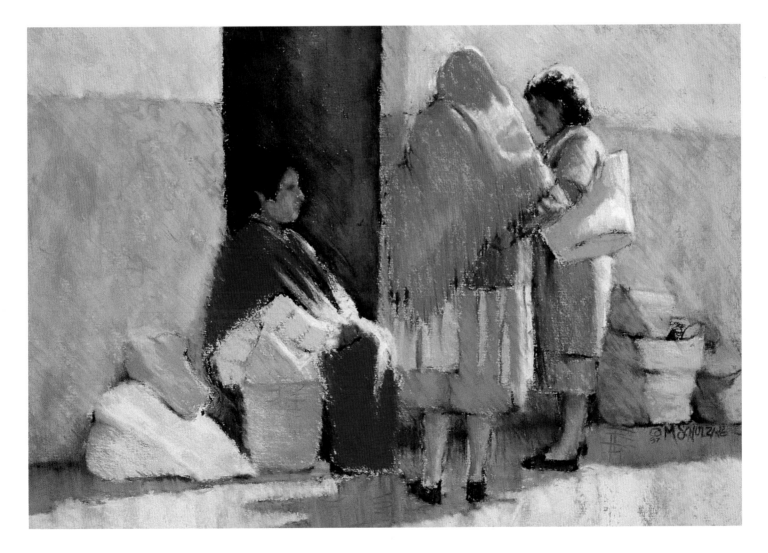

Margot Schulzke
Market Day in Guanajuato (Triad)

10 x 12 in. (25 x 30 cm)
Surface: Hahnemuhle pastel board, White

Schulzke composed this scene from photographs she had taken on the streets of Guanajuato. She edited the elements in these photos to design a spare, strong composition.

I almost always work in series and explore a subject until I have exhausted the possibilities and solved the technical problems. This painting is from a series on a flower farm, which happens to be located near enough to where I live that I can observe the flowers in all kinds of light. These permutations inspire me to make the same scene different in each painting of the series.

Jacqueline Chesley
Flower Farm

30 x 38 in. (76 x 97 cm)
Surface: White folio paper

This painting has so much color in it that Chesley finds it easier to be extravagant in the initial stages and later redefine the shapes and subdue the color. Her objective is to retain the abstract quality of the scene.

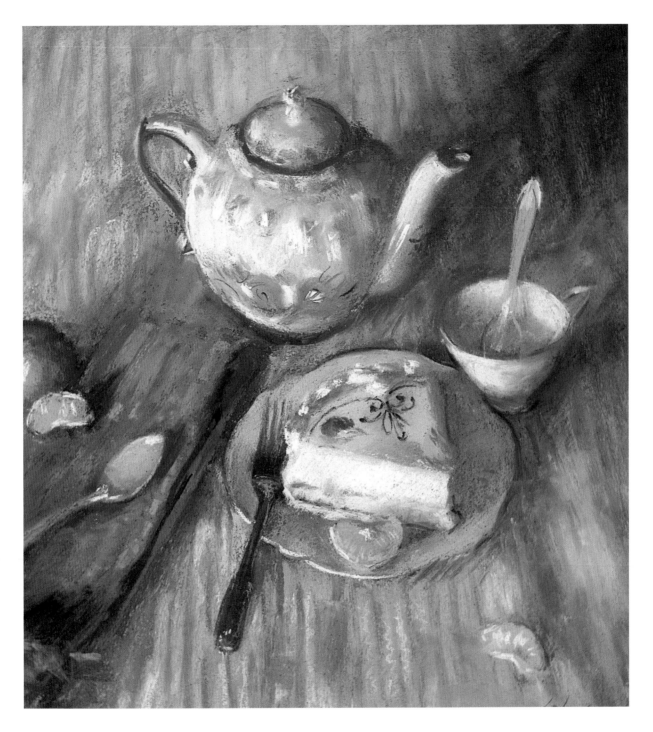

In Slice of Cake, *the striped tablecloth and designs on the teapot and cake excited me aesthetically. I am drawn to areas of extremely chromatic color and love to play them off of each other.*

David Lebow
Slice of Cake

17 x 14 in. (43 x 36 cm)
Surface: Canson Mi-Tientes pastel paper, Gray

Lebow likes to take his time arranging his still-life objects. In this case, he wanted to create the look of a dessert table rather than of a formal composition.

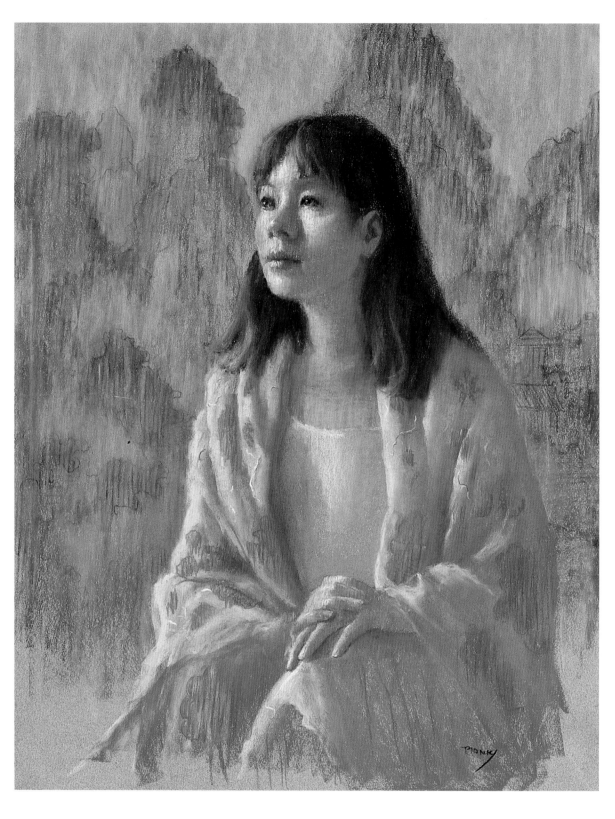

This picture evolved from a friendship with the model, who is a fellow artist. She has that unique quality that makes an artist want to paint her.

Richard Pionk
Young Girl

24 x 19 in. (61 x 48 cm)
Surface: Canson Mi-Tientes pastel paper, Gray

Because this is a portrait, Pionk wants viewers to focus on the model's face. To achieve this, he applies the lightest pastels in that area.

I've been doing landscapes for years. Maybe it goes back to spending all my summers as a child in the Catskills.
I'm just attracted to the landscape. I love the designs that I see—the different shapes and forms, the softness of the
grass. I love traveling the countryside and never cease to be intrigued and captivated by nature's compositions
and designs.

Rhoda Needlman
Row of Purple Trees

18 x 21 1/4 in. (46 x 54 cm)
Surface: Industrial silicon-carbide paper, Black

Needlman saturates her painting surface with water before she begins and continues to intermittently
spray it with water to keep it damp through almost the entire painting process. She likes to allow the
colors to merge and then develops her painting from the resulting shapes.

97

New York is a magical place during the Christmas season, and the Plaza Hotel, which borders Central Park, and the horse-drawn carriages are especially colorful. I used cool colors in an attempt to suggest a cold evening, accenting them with the red bows of holiday wreaths to indicate the time of year.

Roger Salisbury
Outside the Plaza, Christmas Eve

30 x 40 in. (76 x 102 cm)
Surface: Museum board

As preparation for a painting, Salisbury photographs the scene and makes small sketches, recording notes on the colors in the scene to jog his memory once he is back in his studio.

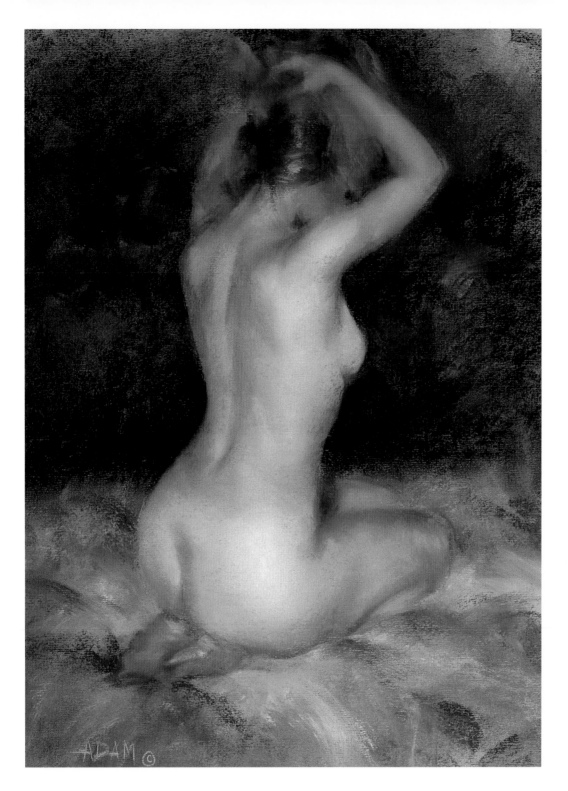

The nude in art has always had my respect, probably because it is quite possibly the most difficult subject matter to paint.

Adam Kelley
The Red Scarf, Nude

18 x 14 in. (46 x 36 cm)
Surface: Canson Mi-Tientes pastel paper

Kelley says the drawing stage in creating a figure painting is extremely important, so he pays special attention to the construction of it as he goes along.

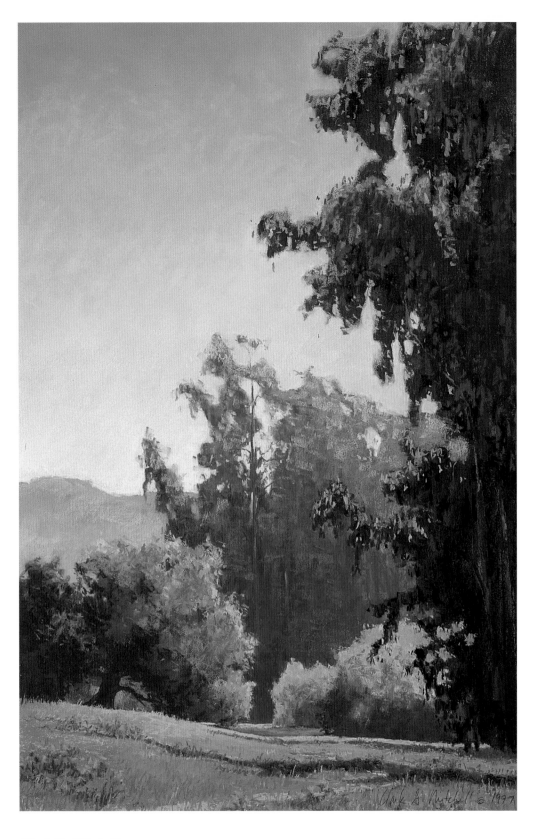

It wasn't actually Easter morning when I did this painting, but by the time it was finished, it really had that feeling to me of early springtime in northern California, with the eucalyptus trees in the distant haze and the path in the foreground wandering through wildflowers.

Clark G. Mitchell
Easter Morning

35 x 23 in. (89 x 58 cm)
Surface: Wallis pastel paper

Mitchell first makes a small sketch on location, and then makes a proportionally larger painting back in his studio. He breaks the scene down into blocks of color, and layers the pastel to give the work a feeling of depth.

These ancient artifacts crafted from the soil tell a story of a proud people who not only utilized the soil but showed respect for it. Even the simplest tools of everyday living were artistically painted and designed. Each of my paintings relates a story of faith and respect for the culture of people skilled in the art of survival.

Don Grzybowski
Adobe Treasures

19 x 22 in. (48 x 56 cm)
Surface: Rag board

This artist uses a nylon brush to carefully scrub and break down the surface of the rag board so it will be more receptive to the pastels. He then blends several colors (sometimes up to a dozen) to create a background and proceeds to develop the image, skipping the drawing stage altogether.

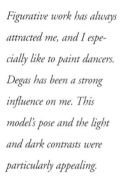

Figurative work has always attracted me, and I especially like to paint dancers. Degas has been a strong influence on me. This model's pose and the light and dark contrasts were particularly appealing.

Annette Adrian Hanna
Black Tights

25 x 19 in. (64 x 48 cm)
Surface: Canson Mi-Tientes buff pastel paper

Hanna blocks in the figure with both hard and soft pastels, using an HB charcoal pencil to reinforce the drawing. She applies the pastels in strokes rather than blending them in order to build up color.

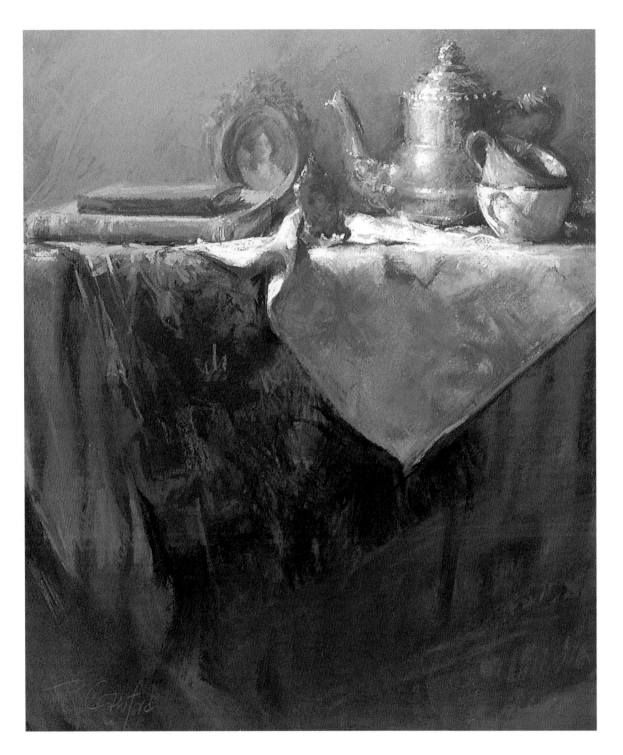

Rainie Crawford
Still Life with a Pewter Teapot

17 x 14 1/2 in. (43 x 37 cm)
Surface: Canson Mi-Tientes pastel paper, Felt gray

Crawford takes great pains to arrange her still lifes, even going so far as to saw the legs off a table on which the objects rest if it is too high for the image she is seeking to create.

I'm an avid collector of small antiques, so it's natural that I would use them in my still-life arrangements. I often include my family photos and those of my "instant" ancestors, which I find at flea markets, for a human connection. But I use them only for reference, not to depict their actual likeness.

I know this little girl's mother, and, in fact, I've painted her too. The girl was preparing for a cultural festival, and I was able to take pictures while they were getting ready. First, I made a black-and-white drawing of the child, but then I liked it so much I decided to paint it in color.

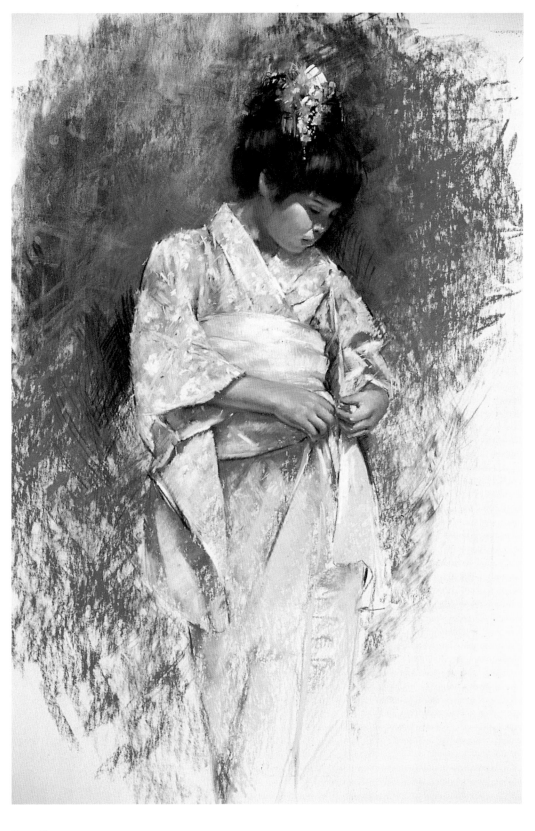

Dee Toscano
The Pink Sash

20 x 16 in. (51 x 41 cm)
Surface: Ersta pastel paper

Toscano first shot a series of photographs of this young girl and, in the process of painting, decided that leaving the background and parts of the image unfinished would add to the delicacy of the work.

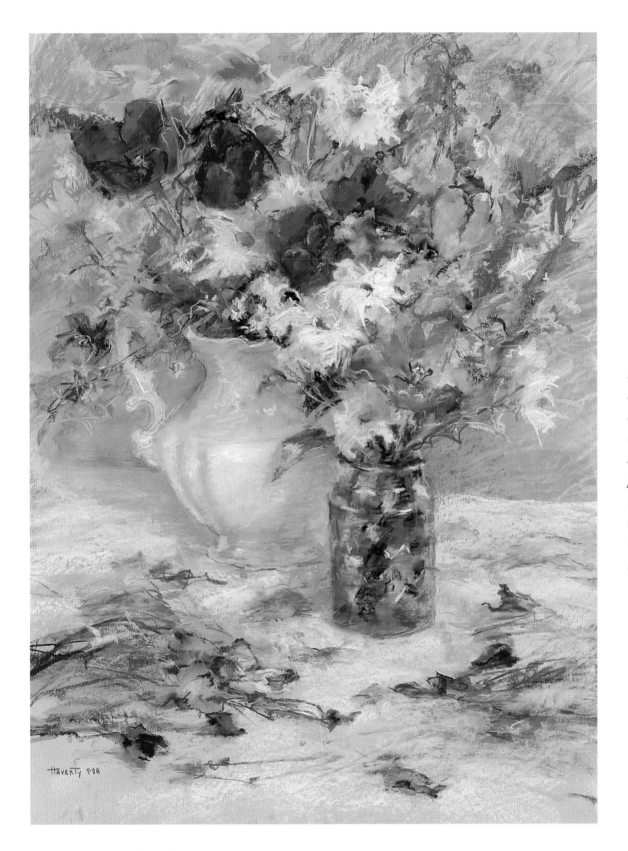

In this painting, I was excited by the color combination of the deep red tulips along with the white daisies. The antique water pitcher was perfect for this arrangement because it has sentimental value to me and because it works well with the theme of falling petals.

Grace Haverty
Fallen Petals

26 x 19 in. (66 x 48 cm)
Surface: Ersta sanded pastel paper

Haverty likes to arrange still lifes in which she can juxtapose dark with light and bounce colors off one another.

105

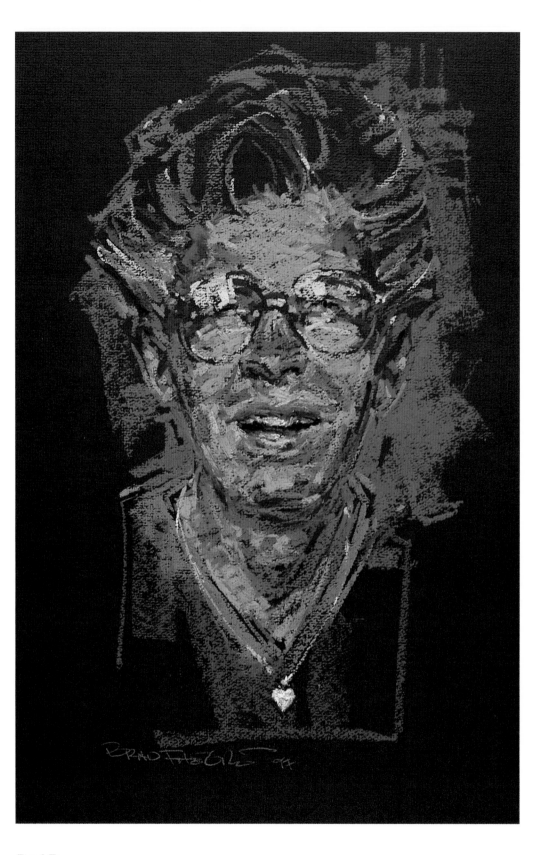

I met Whittier artist Dora Day a decade ago while entering a local art competition. Dora passed away just a week before I was scheduled to give a lecture at the Whittier Art Association, but her family loaned me a video of her, and I used it to create this portrait, which I included in my lecture.

Brad Faegre
Dora

14 x 10 in. (36 x 25 cm)
Surface: Tiziano pastel paper, Green

Faegre varies the lines and direction of his strokes as well as the pressure he applies to the pastel sticks themselves to create a diverse painting surface.

I based this painting on a Dutch landscape, hoping to convey a feeling of mystery—a forest of fading light where tones appear to be quite deep but still have color within them. The crushed-pastel technique seemed the best way to retain the integrity of each color as well as to bring depth and richness to the scene. For contrast, I added the suggestion of something brighter beyond the trees.

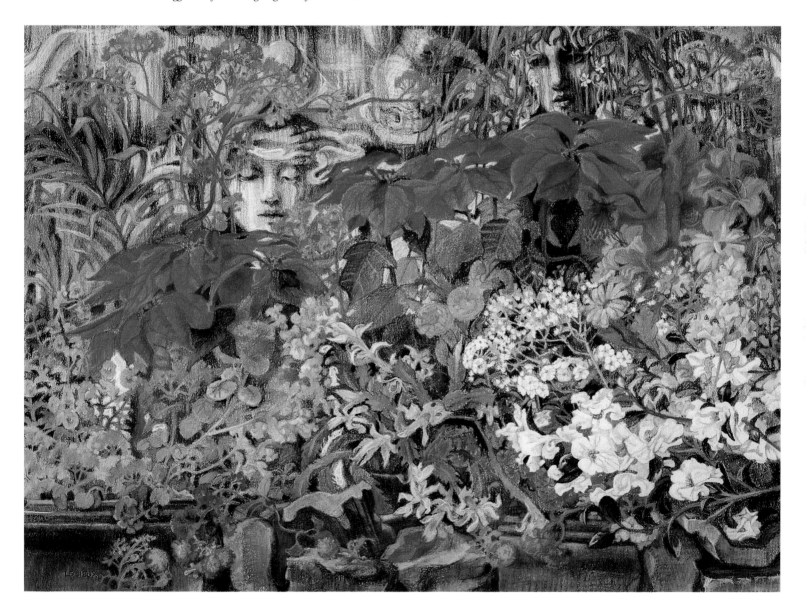

Suzanne Lemieux Wilson
Flowerscape

30 x 40 in. (76 x 102 cm)
Surface: Watercolor paper

Wilson built up this painting in layers of crushed pastel. She created a paste by mixing the pastel with liquid fixatives, pressed it into the surface, and allowed it to dry before the next application.

This painting derived from a blue ginger jar I found in an antiques shop. I then coordinated objects and colors with the jar. I find that bright colors, like those in this work, are very exciting to paint.

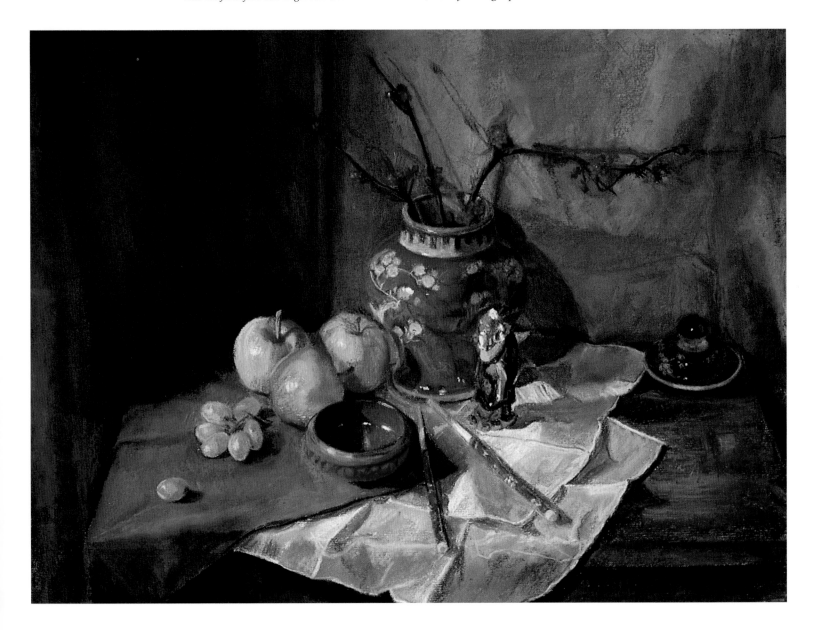

Muriel Hughes
Ginger Jar and Apples

23 x 29 in. (58 x 74 cm)
Surface: Pastel cloth

Hughes likes to add an air of mystery to her still lifes. Here, she achieves this through the play of shadows in the background.

I found this subject at the side of the road on Lake Superior in northern Ontario. It was a crisp, fall morning and the crystal-clear water begged to be painted.

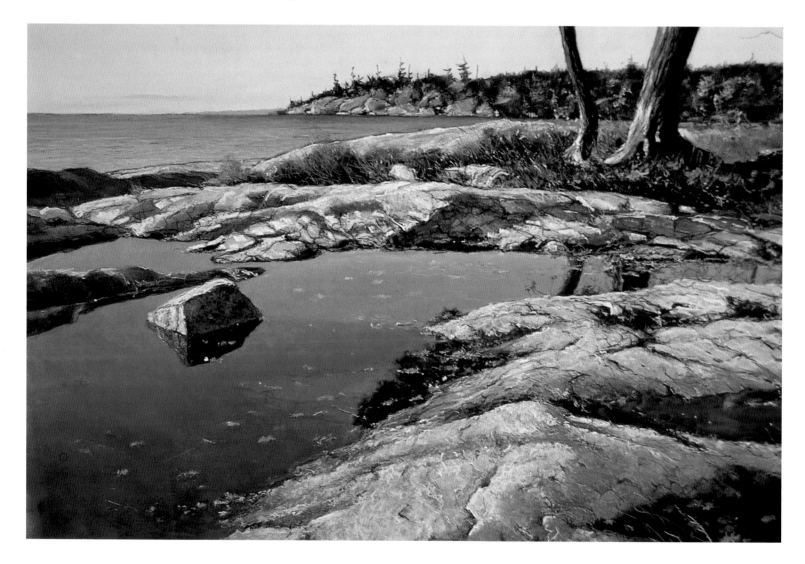

Dave Beckett
Crystal Blue

18 x 34 in. (46 x 86 cm)
Surface: Canson Mi-Tientes pastel paper

When painting the water in this scene, Beckett began with what was under the water and then added the surface color and texture. For the rock, he underpainted to give it a blue glow, reflecting the sky.

Over the last few years I've been doing a lot of sports-related art because the color and excitement fascinate me.

I've always been a figurative painter to an extent, but the figure in sports is particularly exciting.

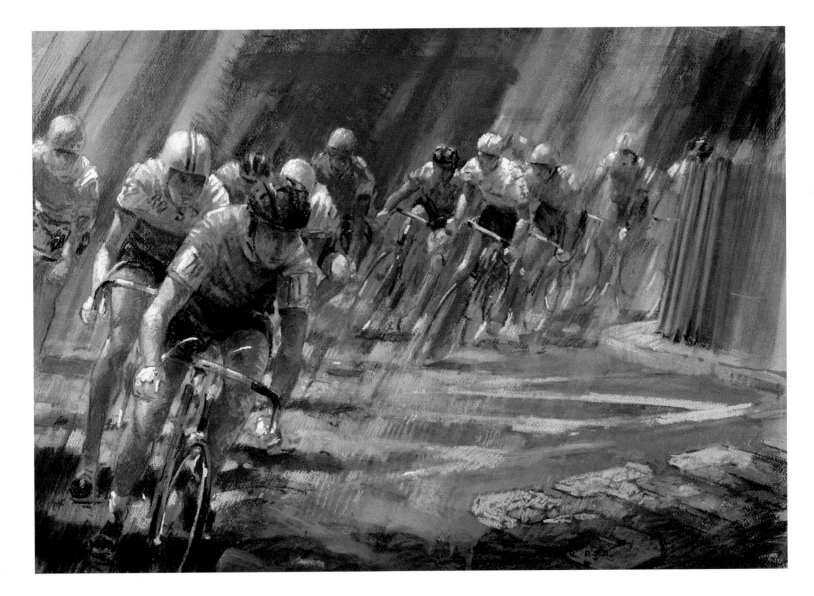

S. Allyn Schaeffer
Breaking Away

19 x 25 in. (48 x 64 cm)
Surface: Canson Mi-Tientes pastel paper

As Schaeffer worked on the painting, he brushed into it with a wide watercolor brush dipped in alcohol, which resulted in the streaky shapes in the background.

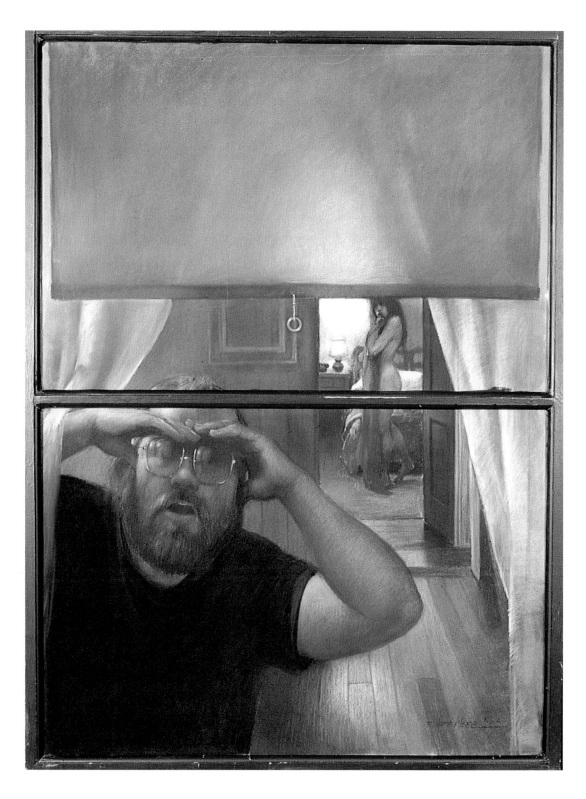

Early in our marriage, my wife and I were plagued by a Peeping Tom. I would continually run to the window yelling, "Who's there?!" Eventually, we moved, and I created this painting in our new house. I always work from life, so I used myself as a model, making faces in a mirror and painting my expression.

Jeff Webb
Who's There?

48 x 36 in. (122 x 91 cm)
Surface: Canson Mi-Tientes pastel paper

For this painting, Webb stretched the heavy-duty pastel paper on a canvas stretcher so it would have a real spring to it. He then blocked in the tones rather loosely and used a stiff brush dipped in a mixture of alcohol and water to turn the pastels into a wash, forming a sort of underpainting.

Painting still lifes from life is wonderful, as I can not only control the lighting but also work in a comfortable environment.

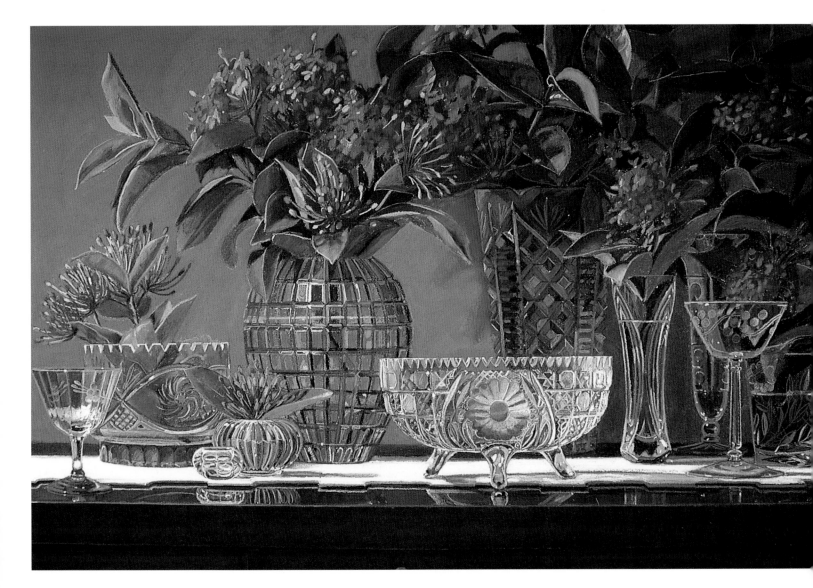

Patty C. Herscher
Pink Ixora

32 1/2 x 42 in. (83 x 107 cm)
Surface: Canson Mi-Tientes pastel paper

Herscher begins all of her paintings with a detailed drawing and never uses fixative on the finished image.

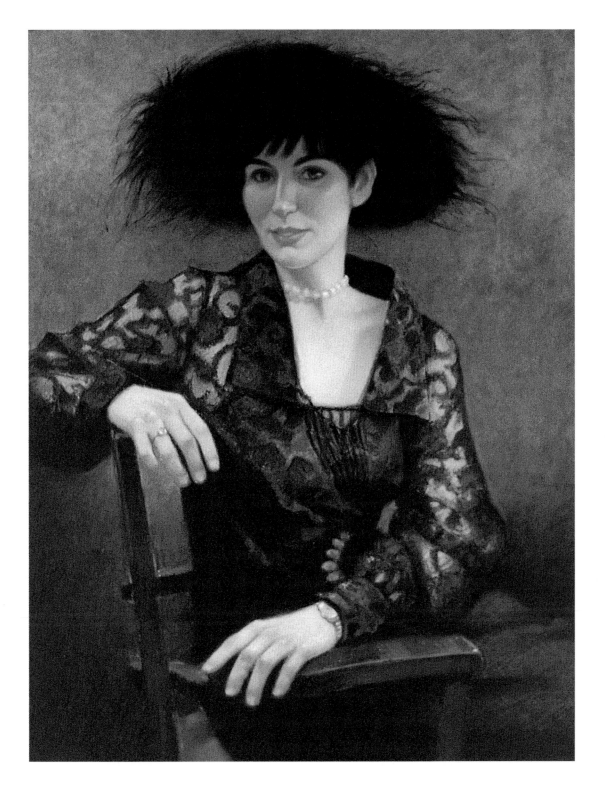

Mary Michele is a hatmaker and dress designer with a shop in North Carolina that features her own creations. Her pale complexion is in contrast to the sleek, black hair, filmy ostrich-plumed hat, satin camisole, and vintage lace blouse. While muted and tonal in color, this pastel presented me with an adventure in rendering texture.

Ann Boyer LePere
Ostrich Plumes and Lace

30 x 24 in. (76 x 61 cm)
Surface: Bainbridge 4-ply rag

LePere first coats the board with a gesso-pumice mixture. When this has dried, she tones it with a watery acrylic wash in warm colors and then makes the initial drawing with hard pastel pencils.

A friend of mine in upstate New York, Sam the hatter represented an old-world tradition that is now nearly gone. This composition of steaming and blocking the hats was too much to resist. This pastel was one of many I did in Sam's shop.

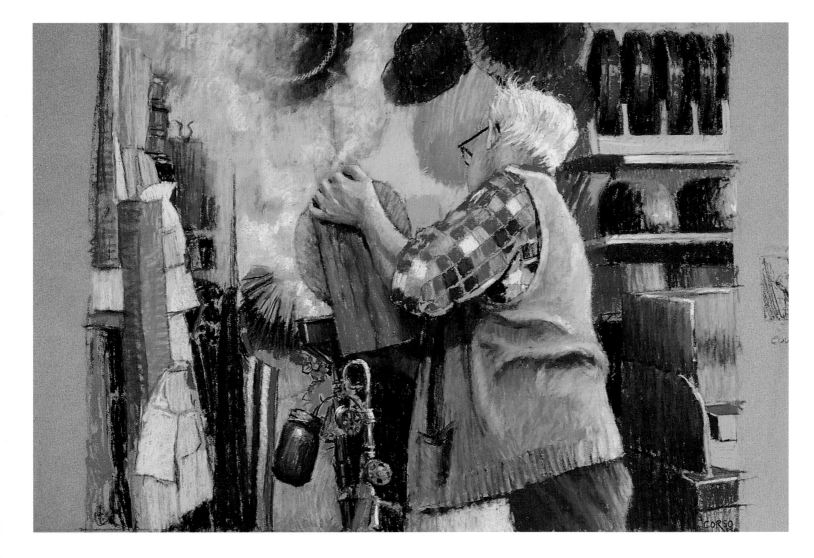

Frank Corso
Steaming Hats

22 x 30 in. (56 x 76 cm)
Surface: Canson Mi-Tientes pastel paper

Corso made this painting on-location in a hat shop. He planned to use it as a study for a larger painting in oil.

My niece has been the subject of many paintings since she was about five years old. Through those years, we've both experienced and shared many transitions. Here, I've endeavored to portray her as a young girl standing on the threshold of womanhood. Perhaps there is a reluctance to leave carefree days behind. I used a limited palette of red, green, and purple to connect the girl and the symbolic imagery of lengthening shadows and the door.

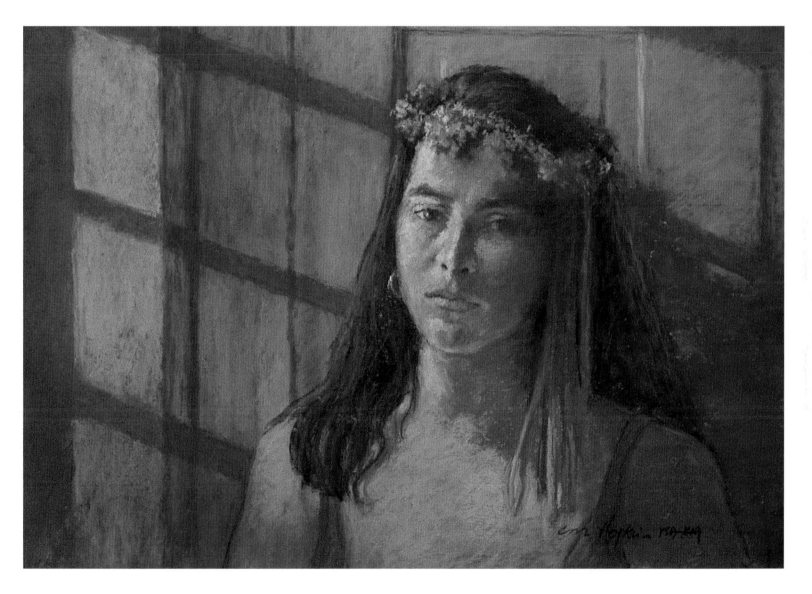

Claire Miller Hopkins
Mardi Gras Is Over

14 x 20 in. (36 x 51 cm)
Surface: Ersta sanded pastel paper, Buff color

The background of this painting is designed to underscore the girl's mood. Hopkins made vertical lines behind the model to echo the ribbons in the girl's hair and play against the rounded forms of her face.

Self-portraiture combines the joy of painting people with the freedom of painting a still life. Every year, I do a self-portrait on my birthday to find out who I am now, and where I am.

Sara-Sue Pennell
SSP97

38 x 28 in. (97x71 cm)
Surface: Canson Mi-Tientes pastel paper, Moonstone

One of Pennell's challenges in this painting was figuring out what view she would paint in the window to the outside. Eventually, she decided to incorporate a landscape from a trip to France instead of painting what was really there: the neighbor's house.

I was attracted to the shapes and colors of these quinces and immediately visualized using a strongly contrasting purple as a backdrop to further emphasize the glowing, warm colors. When I was setting up this still life, I chose to hang the flowers, as if they had been left to dry, and enjoyed creating a feeling of depth by depicting the stems against the muted warmth of the adobe walls of my house. The purple drape in the foreground adds to the feeling of depth and gives the sense of there being different layers in the work.

Janet Hayes
Still Life with Quinces

24 x 14 in. (61 x 36 cm)
Surface: Arches BFK Rives printmaking paper, Light gray

Hayes defines the composition with a vine charcoal drawing, then applies color lightly and quickly with the sides of the pastel sticks. Her strokes are random and painterly.

This is one of the many paintings I have done of trees in the late fall. I try to express the beauty of trees when they are somewhat bare, which is a challenge in terms of drawing and color. Each tree possesses its own unique color and shape. I am always amazed at the infinite variety of silvery gray-browns and gray-greens of barren trees.

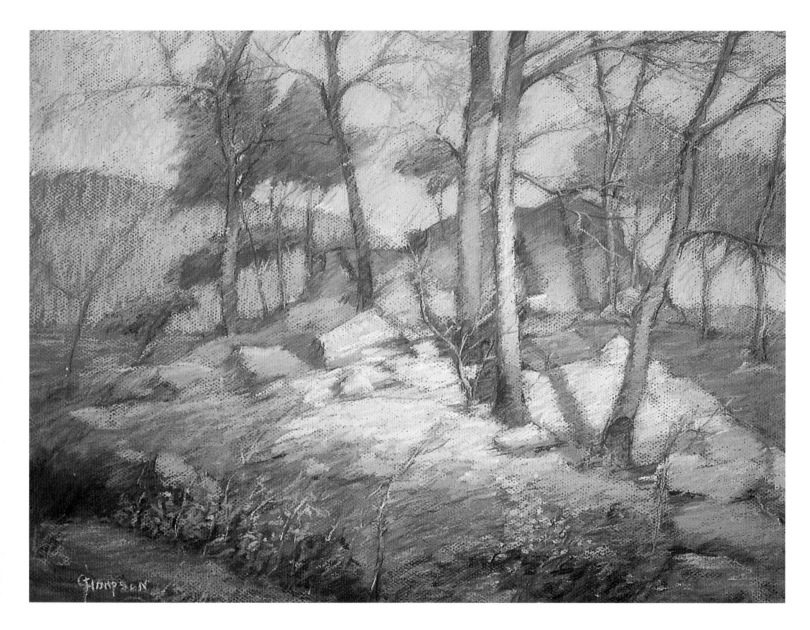

George Thompson
Autumn Along the Hudson

19 x 25 in. (48 x 64 cm)
Surface: Canson Mi-Tientes pastel paper, Gray

Thompson starts with a basic charcoal drawing and applies the pastels in an impressionistic style. He deliberately keeps the yellow grass centered near the gray-brown tree trunks to add contrast and a center of interest.

The Call of Home *is a metaphorical play on the concept that you can't go home again. The woman in the image pauses with her letter to home, reflecting on her past. The picture hanging on the wall behind her represents her homeland. The shuttered window suggests that she may be in a new land that will become and remain her new home.*

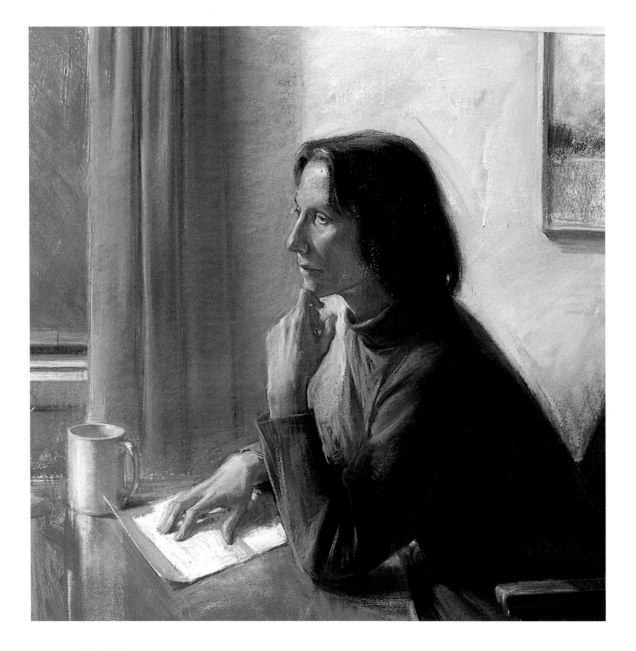

Dan Gheno
The Call of Home

30 x 32 in. (76 x 81 cm)
Surface: Pastel cloth

Gheno likes to paint on pastel cloth because the surface is very even, like paper, but the cloth attracts the pastel like a magnet.

I enjoy painting in the country and am always fully aware of what is going on around me. The zip of a passing bee or the scent of newly cut hay sometimes intensifies my inspiration more than the subject itself and helps me to capture the moment.

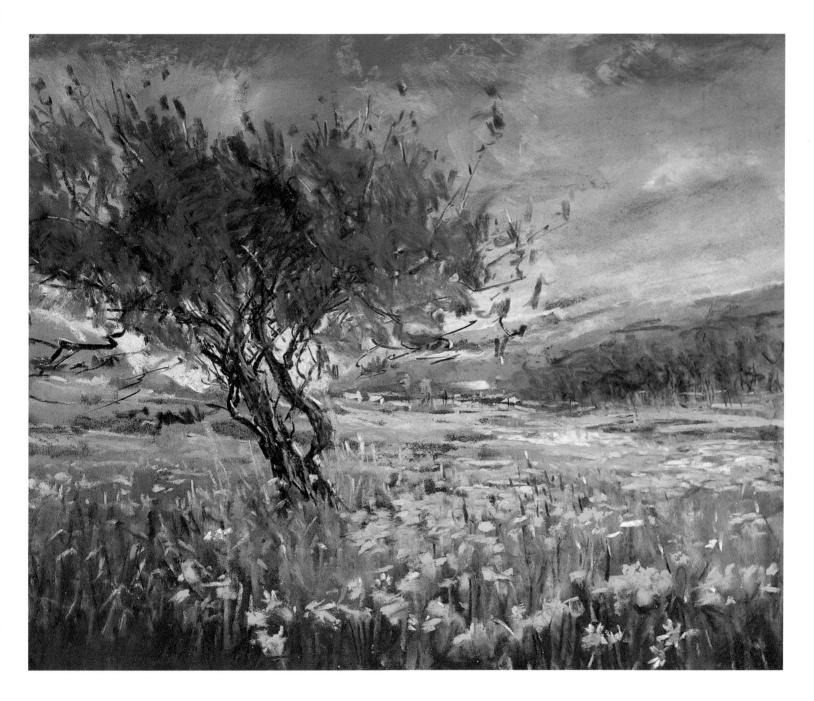

Willi Hoffmann-Guth
Spring in Provence (Near St. Tropez), France

8 x 10 in. (20 x 25 cm)
Surface: Sandpaper

For Hoffmann-Guth, technique has to follow mood. Sometimes he thinks color and winds up focusing on the light in a scene, sometimes he thinks light and then is drawn to the colors. In this work, recording the colors was his first impetus.

I like to go to different events in order to get new painting material for my figurative works. For example, Texas Tech Ranching Museum has Ranch Day every summer, during which ranch activities are demonstrated. Volunteers dress in authentic costumes for the occasion. The young lady in this painting, sitting on a bright quilt cording wool, was very colorful and appealing.

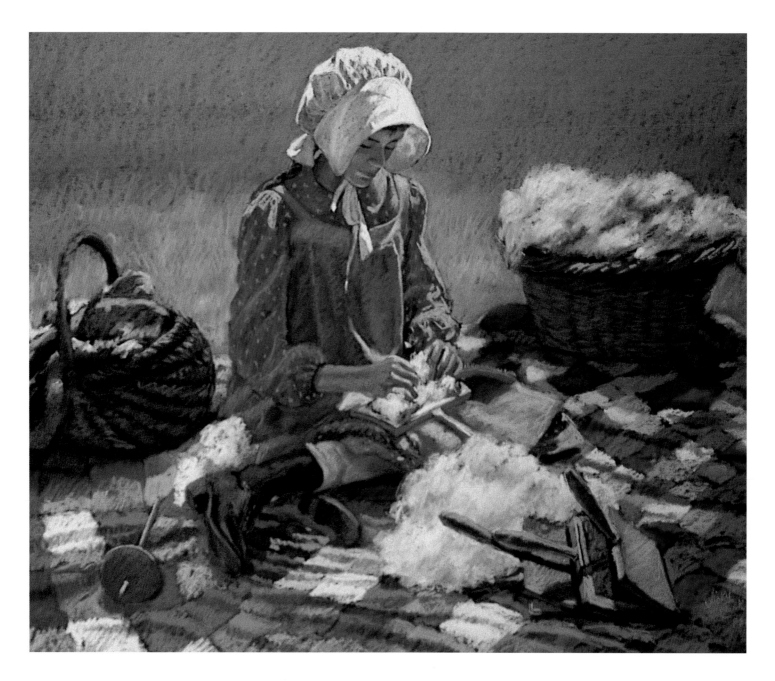

Vicky Clark
Cording Wool

16 x 20 in. (41 x 51 cm)
Surface: Ersta sanded pastel paper

Clark primes her surface in an unusual way, using a mixture of ebony and Jacobean Minwax furniture stain in a middle value of warm gray. She paints with both pastel pencils and hard and soft pastels in a scumbling manner, juxtaposing bright colors.

I asked this fellow—a local model, actor, and clown—to look at the paintings hanging in my studio and react to them. To my delight, he immediately picked pieces of purple and red cloth from my drapery bin, stuffed them under a painting of a nude, and mimicked that painting, modifying it just slightly, but hilariously.

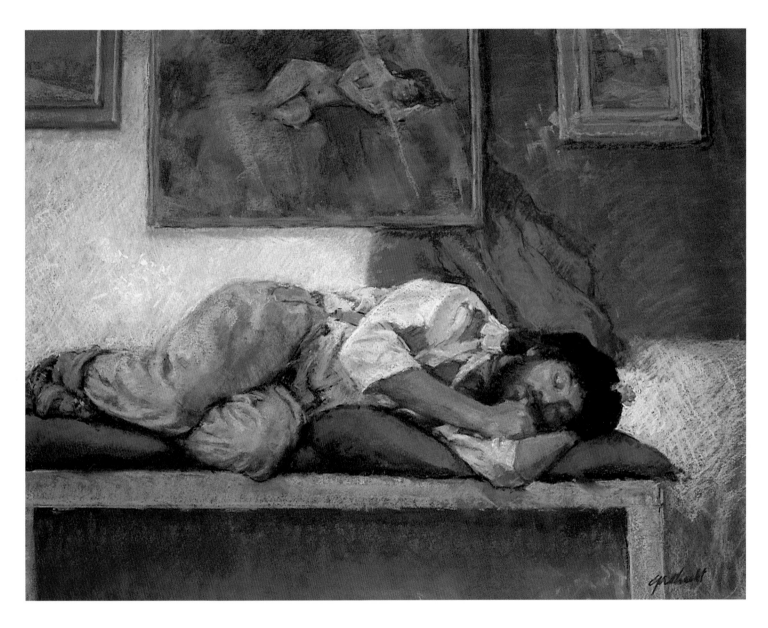

Bob Gerbracht
Sleeping Beauty

19 x 25 in. (48 x 64 cm)
Surface: Canson Mi-Tientes pastel paper

Gerbracht first maps out his lights and shadows, then applies midtones over these areas. Afterward, he modifies these tones using many colors and applying the pastel with separated strokes.

For this painting, I worked from a photograph of my Himalayan cat, who occasionally left her place in the sun to offer encouragement.

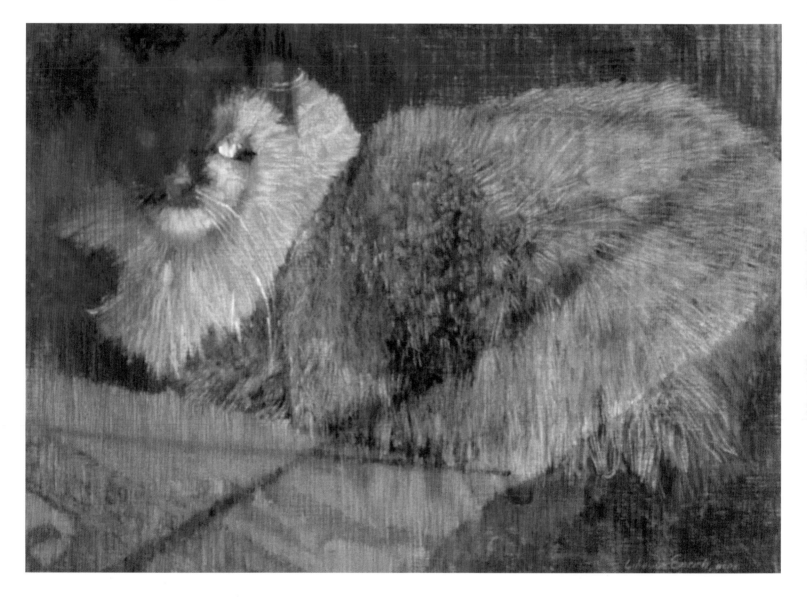

Lilienne B. Emrich
Cat

23 x 29 in. (58 x 74 cm)
Surface: Flint cloth

After making a line drawing, Emrich establishes the dark and light areas using hard pastels in two colors: blue for cool and burgundy for warm. She then stumps the image down (the only point in the process at which she blends) and finishes it in full color.

It was the last day of autumn, before that last gust of wind came and blew the leaves off the trees. I stood out there in this park and photographed it, soaking up the whole atmosphere. I was very aware of my surroundings: the coolness of the air, the dampness, the overwhelming peace and tranquillity. That's what I wanted to be able to show. I want the people who look at this painting to be able to experience the same thing I did when I was there.

Judy Pelt
Beside Still Waters

20 x 20 in. (51 x 51 cm)
Surface: Lipari pastel surface

Pelt composed this painting from a number of photographs she took at a local park on a rainy day. She scumbled the pastels so that the layers of color would show through each other.

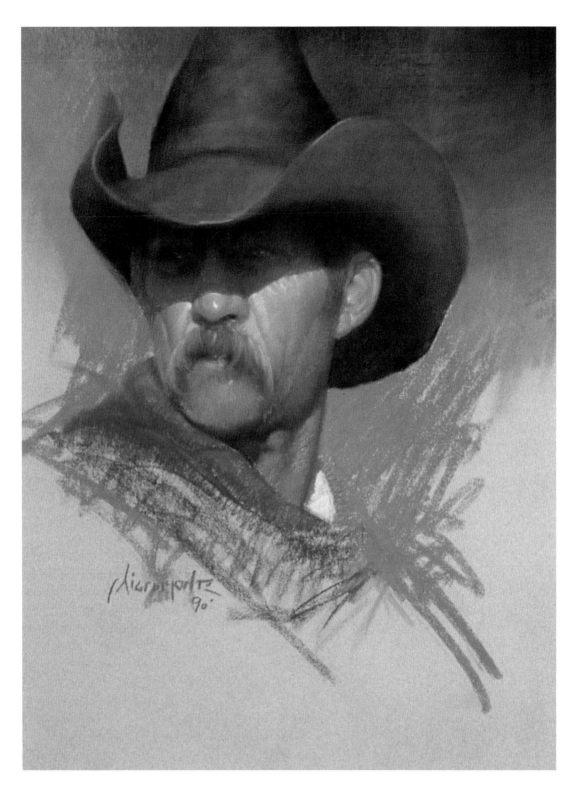

Cowboy is a study of sunlight on skin. Warm yellows, oranges, and reds dominate the light areas, while blues, cool greens, and violets were reserved for the shadows. The key element to this piece was the cast shadow across the face. I had to convince the viewer that the shadow was in fact a shadow and not just a dark area covering the top of the face.

Vincent S. Chiaramonte
Cowboy

24 x 19 in. (61 x 48 cm)
Surface: Canson Mi-Tientes pastel paper

Chiaramonte first completes a line drawing in vine charcoal, then establishes the lights and shadows using the sides of the pastel sticks.

125

The model in one of my workshops wore a dress reminiscent of the twenties. She took a pose with a certain attitude. I added the scarf and pearls for a final touch, and she became the inspiration for this painting.

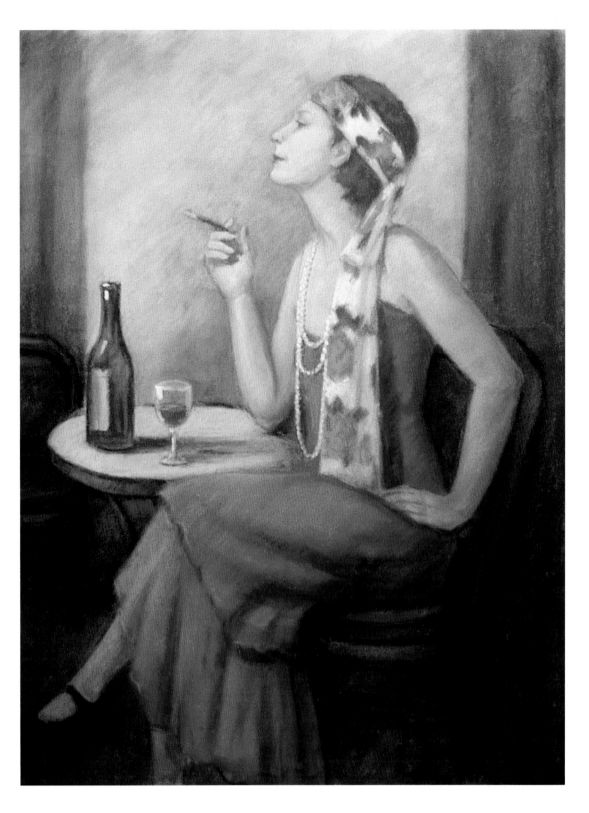

Mary Hargrave
The Sophisticate

30 x 24 in. (76 x 61 cm)
Surface: Pastel cloth

In order to create a firm work surface for her painting, Hargrave stretches the pastel cloth over canvas stretchers and places museum board between the cloth and the stretchers.

I paint all the time. I'm rather keen on the type of vessel in this painting. I remember this French fishing boat from many, many years ago when I happened to be in the harbor on another boat. I remember making a couple of sketches at the time.

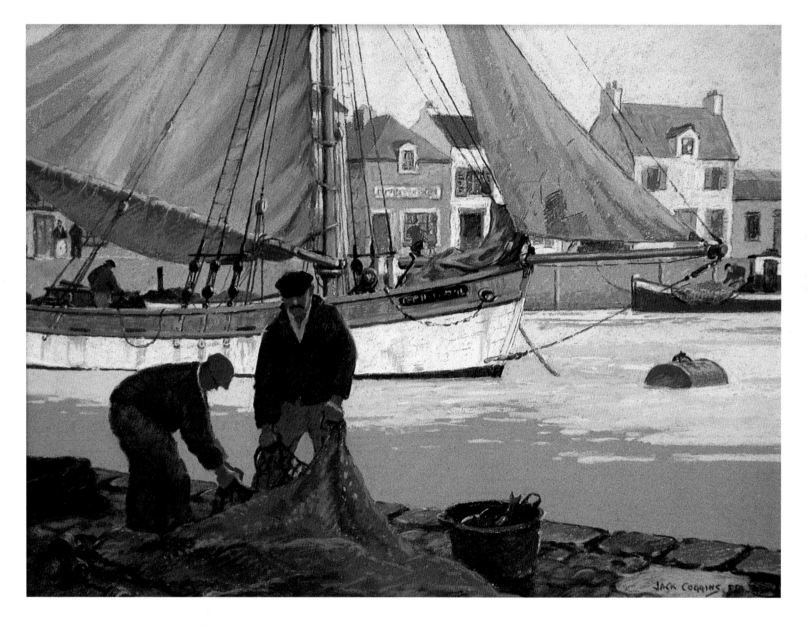

Jack Coggins
Fishing Harbor, Brittany

16 x 21 in. (41 x 53 cm)
Surface: Ersta pastel paper

Coggins devised this composition from what he knows about the fishing boats and harbors pictured. He started by making many small compositional sketches to work out the design for the painting.

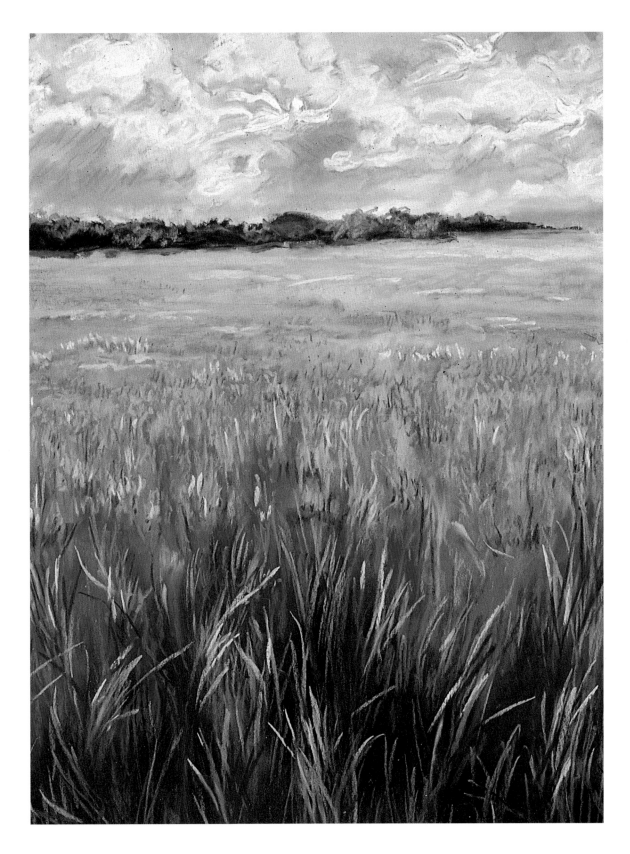

Angelic Harmony *reflects nature in harmony. The angelic figures soar in the sky over a brilliant-yellow wheat field, enhancing the exhilarating sense of movement that activates the entire composition.*

Marion Strueken-Bachmann
Angelic Harmony

20 x 16 in. (51 x 41 cm)
Surface: Ersta sanded pastel paper, #713E natural

Strueken-Bachmann unifies this painting by interspersing the soft-blue florals with the tall, swaying wheat stalks in the foreground. The wheat stalks, in turn, mirror the color and movement of the sky.

My work focuses on the grandeur of small, fleeting moments in nature. Rather than paint the landscape as an object, I approach it as an expression of a conversation. All the elements combine to give voice to a moment that speaks a unique thought. It is visual poetry.

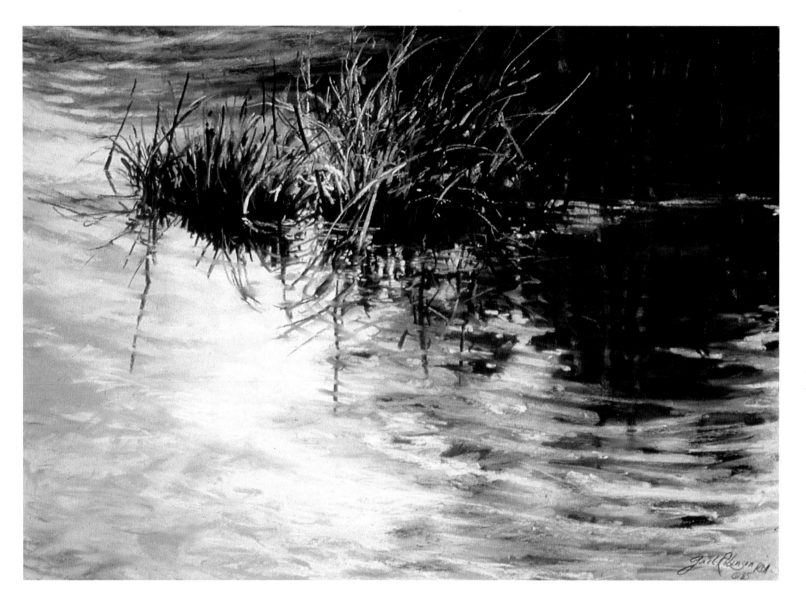

Gail E. Robinson
Contemplation

22 x 30 in. (56 x 76 cm)
Surface: Arches 300-lb. watercolor paper

Robinson tends to work from deep space to the foreground. In this case, she works from the deepest part of the reflections up through what's real—meaning the leaves and grass—up through to the reflections, where the light is glinting.

It isn't hard to find inspiration when you live in Maine. While snowshoeing through the woods early one morning, I came upon a small stream at the foot of a hill. Though it was encrusted with ice, the water still flowed through the winterscape, creating the only sound in the forest. I knew I had to return to this scene, to try and capture its tranquillity in the early-morning light.

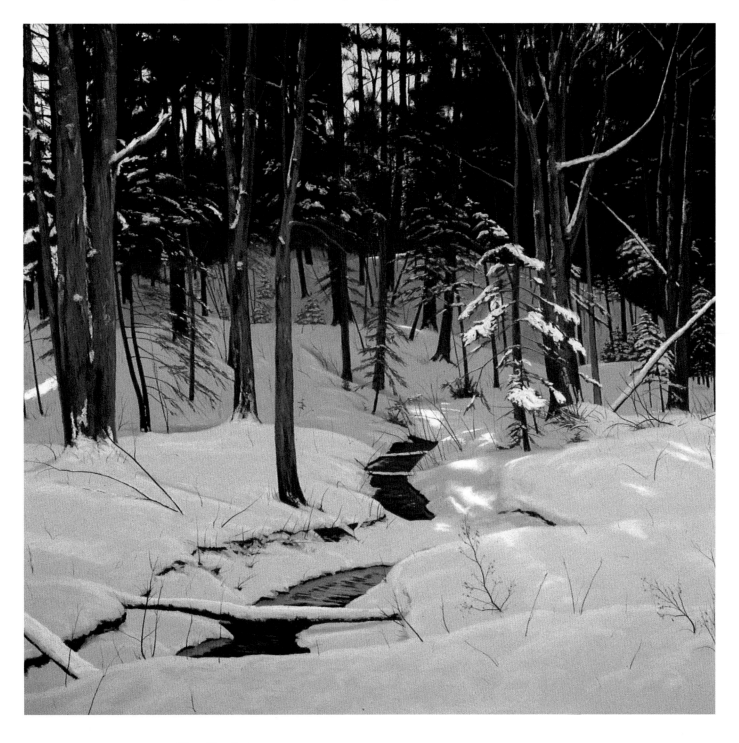

Timothy Parks
In the Deep Woods

32 x 40 in. (81 x 102 cm)
Surface: Masonite

Parks first paints a plein air oil imprimatura on a gessoed Masonite board, working quickly to capture the interplay of light and shadow before it changes. Back in his studio, he covers the board with a mixture of pumice, water, and acrylic medium to create a rough surface on which to apply the pastel.

I did the photo shoot for this painting at a studio in New York City. I solve many compositional problems in the photo shoot. There, I can experiment—I let things happen. There are subtleties you just cannot pre-plan: an attitude or the way a model's hand moves or the way she's leaning forward—accidents that just happen. In the painting itself, I try to keep the colors very close together and let just a few things come forward: the red of the lips, the fire in the hand that's lighting the cigarette. That little bit of color will sort of just light up the entire painting.

Joel Spector
Girls' Talk

16 x 20 1/2 in. (41 x 55 cm)
Surface: Sanded pastel paper

The liquor importer who commissioned this painting wanted an image of a nostalgic 1950s nightclub scene. So Spector hired models and rented period costumes and had a photo shoot to create reference material.

Critiquing Your Own Work

by Alden Baker

"A good painting," said the fine American landscape painter Edgar Payne, "requires nobility in its concept, variety, rhythm, repetition, unity, balance, and harmony in its composition." The grandeur of this statement is enough to scare any aspiring artist into another field of endeavor.

Those students who have that important burning desire to express themselves through painting, however, will love the years of learning the basics and of practicing. It will be a joy—and it's a good thing, for there is no other way to become an accomplished artist.

In pastelling, or any other painting medium, the basics begin with drawing, then values, color, and finally, composition and design. In the old days, you had to graduate from the antique class (drawing from plaster models) before you were permitted to work with color. It was a good system because by then, you not only knew how to draw, but you knew your values, an all-important ingredient in the creation of a strong work of art. It is after mastering these basics that a serious artist goes on to develop personal technique and, maybe, originality. Another landscape painter, the English artist Leonard Richmond, put it this way: "Invention follows when knowledge leads the way."

I start with these statements because in order to critique artwork, there has to be a foundation of basics or fundamentals upon which to make a judgment—and don't think that good abstract art doesn't contain some basics. It may not contain traditional drawing, but it usually displays good color relationships, effective use of values, a well-balanced design, and interesting technique. Of course, once you get into Minimalism, you're dealing with something quite different. Such work usually doesn't have much to do with the basics, except maybe a feeling for spatial relationships. Judging this kind of work is for art dealers and modern museum directors, who have a language all their own. Even Matisse is said to have announced to a new group of students who were wildly expressing themselves, "We will begin by learning to draw."

This section is concerned with representational work by artists who have taken or are taking the time to learn the basics. After all, how can you tell if you have drawn something well if you know nothing of losing edges or of values, and how can you capture the character and beautiful color of nature if you have never worked outdoors? You can't. There is no shortcut to becoming a fine artist. If you don't go the distance, it shows.

Mary Beth McKenzie *Loft Interior*

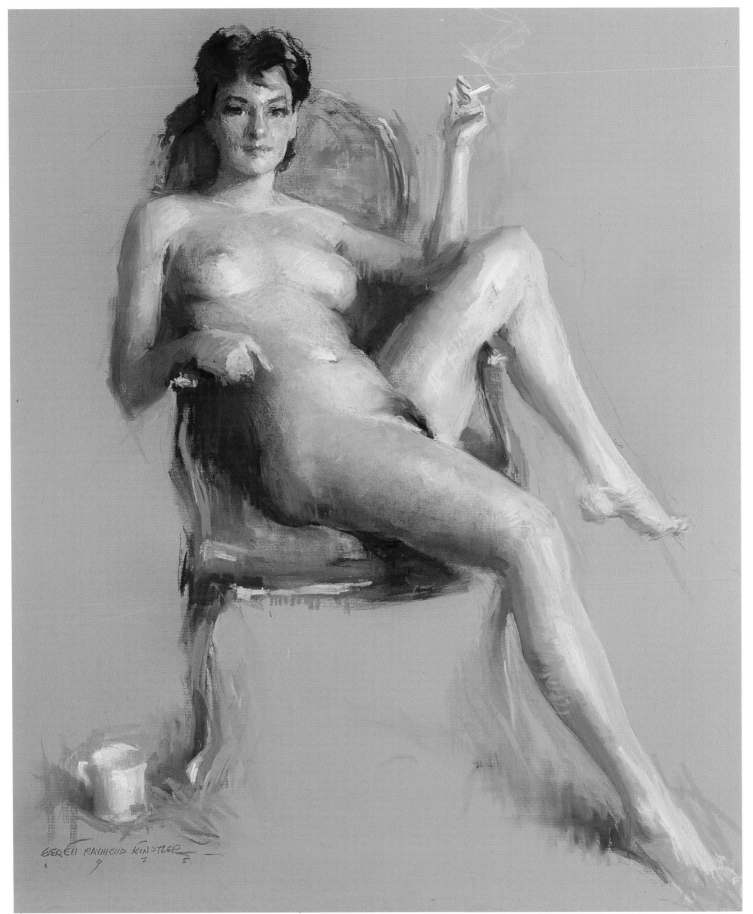

Everett Raymond Kinstler *Coffee Break*

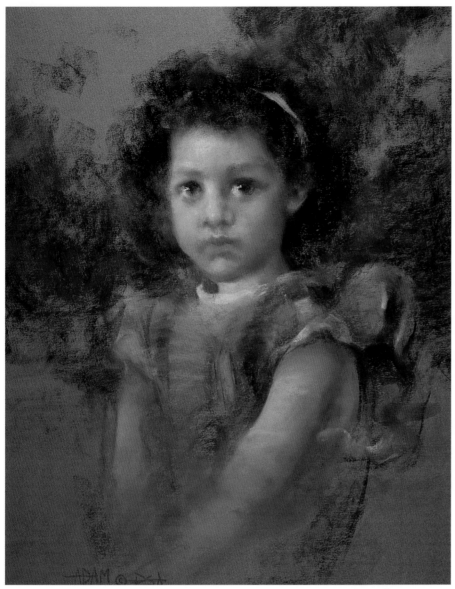

Adam Kelley *Brown Eyes*

Fay Moore *Pasture Sycamore*

Have You Remembered?

Here are some reminders of what to avoid as well as what to remember in order to save time and create a work of art that will be critiqued favorably. (These recommendations are directed primarily at students.)

The Beginning

Standing while you work is one of the biggest known deterrents to error. By doing so, you can step back from your painting and obtain a better view in order to judge if all is in balance—something you can't always tell if you are sitting in front of the work. If you do have to sit, though, try to do so as far back from your work as possible and use a mirror to look over your shoulder at the painting. I know some very good artists who sit and are therefore prone to errors in drawing the figure because they forget or are too lazy to use a mirror. Sometimes they simply think they are so good that such precautions are unnecessary.

It is a good idea to begin a painting by placing a cross in the middle of your paper or board. This reminds you to avoid placing your focal point or horizon in the middle of the painting. Not only would doing so be a poor division of space, it would also be boring. The only thing that can be centered is a small portrait head. In large portraits, the head is usually off-center. Acquire the habit of using a viewfinder to choose your subject when working outdoors. After you have found your subject, make a small sketch of it, working out the pattern of dark and light and the general design. This exercise is valuable in preventing compositional errors and is also a good practice. It must be—all the best artists do it.

Avoid reflected light and color on your paper from your clothing (it throws off your color and values) by wearing neutral colors. Similarly, if you're standing on sand or some other reflective surface, place a neutral tarp or blanket under your easel. Never have sun on your paper. It throws off your values.

It goes without saying that if you're outdoors, and you're not working with a French easel, you should have a chair on which to place your pastels. You should also wear clothing appropriate for the weather and have on hand bug spray, sunscreen, an umbrella, water, food, and whatever other items you may need.

Composition

Whether you're doing a landscape, a portrait, or a still life, remember to avoid placing objects—rocks, trees, people—all in a row or on a line, or to make them symmetrical, which will produce a static composition. Also, avoid equal-size subjects, equal spacing of objects, and crowding of objects; if an object doesn't help the composition, then eliminate it. Eliminating and moving objects around in this way is harder than just copying what you see, but it will help you produce more effective paintings.

Experienced painters know that unity of tone and an accurate value mass are difficult to maintain when they become obscured by fussy details. Capturing the character of a subject simply and boldly is essential in order to create a successful work of art, and it's a lifelong struggle for artists. *Simplify* should be the most important word in the artist's lexicon.

Finally, have you left an opening in the fence, the wall, the hedge, etc., to free the viewer's eye to travel an interesting path through the composition? Have you accentuated opposing angles in your picture, so that the thrust of the line or action isn't all in one direction? If you haven't, you can discover such an error by looking at the work upside down or backwards in a mirror.

Mary Close *Vertical Sequence*

Technique

The renowned landscape painter Emile Gruppe made an interesting comment relating to technique in his book *Gruppe on Color:* "The important difference between tight and loose painting is that meticulous work can be copied—even a reasonably clever student could do it—but loose, spontaneous work is full of accident and inspiration. And great paintings done in this manner can never be duplicated. The painter himself doesn't know how he got some of his effects." Such spontaneity and inspiration can be realized only after building a firm base of knowledge and by practicing. Too much reality in a picture can be a disappointment to those artistic souls who respond to mystery and the imagination.

Mannered work should be avoided as well as the meticulous. Such work usually results from the artist painting the same subject all the time. Artists should paint what they feel strongly about and not according to a formula.

John T. Elliot *Norman Rockwell Church*

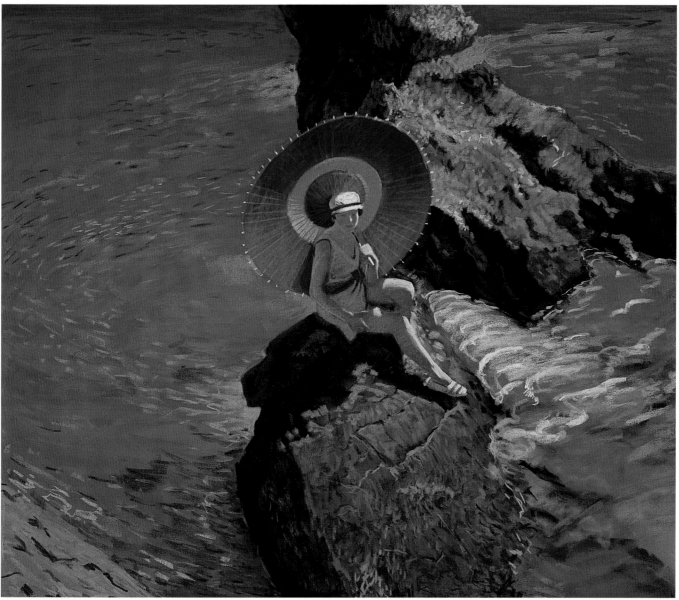

Joel Spector *Rowena at the Riviera*

136

Dinah K. Worman *Taos Plaza*

Color

Does your work lack vitality? Perhaps you only paint indoors. If you do, your color is bound to suffer. As PSA Critiques Chairperson, I often advise artists whose work lacks beautiful, lively color to paint outdoors. It was mainly the Impressionists who taught us how to see vibrant color. Before them, the color in paintings was tonal, meaning that artists saw the local color but not the subtle color within it. Artists like Monet learned that you can't stare at a thing to determine its color. Your eye dulls when looking at objects in isolation. To begin with, it's an unnatural act; normally, our eyes dart from one thing to another, seeing color in a fresh way, and this is what the artist must do. Always look at your subject obliquely. If you want to know the color of distant hills, look quickly at the foreground and then back at the hills. The true color will be revealed because you have seen the hills in relation to their surroundings. This is, of course, the way to see true color anywhere—indoors as well. If you want to know the color of someone's hair, look at the background and then back at the hair quickly.

When first studying nature's color outdoors, paint in strong sunlight, when contrasts are greatest. This makes the artist generally more sensitive to color. You will find that the darks are not as dark as you thought. To test this theory, hold up a piece of black paper or anything black in the shade. You will see how comparatively light in value the shadows are.

When you have learned to see the fresh, vibrant colors in nature, you may notice that the color in photographs is darker and duller than you realized. It's better not to work from them at all, but if you have to, you will have learned that their color must be enhanced.

Timothy Parks *Street Scene*

137

Suzanne Lemieux Wilson *Imaginary Landscape (After Verster)*

Originality

Many artists try to bypass the basics and the study of the great works of art and do something different, even shocking, to get people's attention quickly—and often they succeed in doing so. But this is the path of the novice. True art is deeply felt, not manufactured. Real artists do not paint for applause alone—though God knows we all appreciate it—but because they have to. It is their way of expressing themselves and is what thrills them

Originality doesn't mean inventing new art principles but rather creating new styles and methods of approach, all of which must be based on the fundamentals if art is to remain the application of skill and taste founded on aesthetic principles and knowledge. With the advent of Conceptualism and Minimalism, however, there is a dichotomy of thought on the subject—but not in my mind.

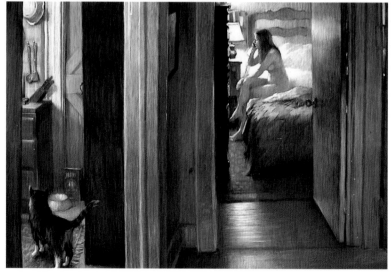

Jeff Webb *Home*

Wende Caporale *Young Boy Surrounded by Folk Art*

The Finish

Have you captured the big effect—that beautiful something that inspired you initially? If so, stop. If you have overworked your painting, brush it out and start over, or forget it and work on something else.

Have you examined your picture upside down to spot compositional flaws? It's not always easy to know when a painting is finished or whether it's good. Often it is necessary to live with it a few weeks before deciding.

Artists—good artists—are frequently poor judges of their own work. My mother, who was a fine painter, once showed me a recently completed picture of the seaside about which she was most enthusiastic. She said, "Don't you love it?" I looked at it a while, trying to see what she saw, but finally said, being an honest type, "No, I don't love it." She had become enthused over some aspect of the picture. Perhaps she discovered a new way of handling the medium or making a color effect—I don't recall. It can happen to all of us. So, an objective opinion can be most helpful, although sometimes hurtful.

Since some form of beauty is that to which most true artists aspire, I would like to close on an encouraging note I read in John F. Carlson's great book, *Elementary Principles of Landscape Painting*. He said, "Pure beauty is an orderly quantity which seldom emanates from imbeciles or charlatans."

Not just anyone can be an artist. Ours is a fraternity of talented, intelligent individuals all questing after order and beauty in the world. It's a noble cause.

Donna Neithammer *Corner of the Barn*

Directory of Artists

Rozsika Ascenzi
140 Rutledge Street
Brooklyn, NY 11211
718.852.2425

Alden Baker
22 Mountain Avenue
Summit, NJ 07901
908.277.2060

Martha Bator
3432 Stratfield Drive NE
Atlanta, GA 30319
404.266.9636

Francois Beaudry
C.P. 856 Succ. Des Jardins
Montreal, Quebec H5B 1B7
Canada
514.281.1089

Dave Beckett
1973 Marchmont Road, RR#2
Orillia, Ontario L3V 6H2
Canada
705.325.6809

Mary Vitelli Berti
6A Rochester Court
Huntington, NY 11743
516.427.2640

Larry Blovits
0-1835 Luce SW
Grand Rapids, MI 49504
616.677.1765

Jonathan Bumas
99-34 67th Road, Apt. 6A
Forest Hills, NY 11375
718.459.5903

Foster Caddell
47 Pendleton Hill Road
Voluntown, CT 06384
860.376.9583

Marilee B. Campbell
316 E. 2950 North
Provo, UT 84604
801.375.8244

Wende Caporale
742 Titicus Road
Studio Hill Farm
North Salem, NY 10560
914.669.5653

Jacqueline Chesley
95 Clark Avenue
Ocean Grove, NJ 07756
908.775.2974

Vincent S. Chiaramonte
920-19th Street
Rockford, IL 61104
815.398.6657

Vicky Clark
607 SW Avenue I
Seminole, TX 79360
915.758.2863

Mary Close
129 East 82nd Street, 7C
New York, NY 10028
212.988.0232

Jack Coggins
P.O. Box 57
Boyertown, PA 19512
610.367.9250

Frank Corso
138 Cable Avenue
Salisbury, MA 01952
508.465.2672

Rainie Crawford
21 Mountain View Avenue
New Milford, CT 06776-2497
860.354.1894

Bill Creevy
6 Greene Street
New York, NY 10013
212.925.4524

Thelma Davis
6666 Acorn Hill
Placerville, CA 95667
916.621.0706

Doug Dawson
8622 West 44th Place
Wheat Ridge, CO 80033
303.421.4584

Christina Debarry
15 Ferncliff Terrace
Short Hills, NJ 07078
201.564.9373

Leslie Delgyer
168 Westervelt Avenue
North Plainfield, NJ 07060
908.755.3639

Gil Dellinger
5460 Hildreth Lane
Stockton, CA 95212
209.946.2246

Leslie B. DeMille
50 Cathedral Lane
Sedona, AZ 86336
520.282.9456

Diana DeSantis
34 School Street
East Williston, NY 11596
516.747.7737

Connie Dillman
306 Thunderbird
El Paso, TX 79912
915.584.4560

Carol Duerwald
46 Mile Drive
Chester, NJ 07930
908.879.5722

Anatoly Dverin
9 Oak Drive
Plainville, MA 02762
508.695.2931

John T. Elliot
304 Highmount Terrace
Upper Nyack, NY 10960
914.353.2483

Lilienne B. Emrich
3215 N. Tacoma Street
Arlington, VA 22213
703.532.2011

Hal English
136 Heather Hill Drive
West Seneca, NY 14224
716.674.0408

Brad Faegre
P.O. Box 904
La Habra, CA 90631
562.694.2585

Juanita G. Farrens
6164 Marshal Foch
New Orleans, LA 70124
504.482.0528

Frank Federico
25 Marshedaug Road
Goshen, CT 06756
860.491.9128

Barbara Fischman
41 Union Square
New York, NY 10003
212.463.8530

Alan Flattmann
1202 A Main Street
Madisonville, LA 70447
504.845.4930

Tim Gaydos
89 High Street
Montclair, NJ 07042
973.746.6931

Bob Gerbracht
1301 Blue Oak Court
Pinole, CA 94564
510.741.8518

Dan Gheno
320 W. 56th Street, #3H
New York, NY 10019
212.246.6927

Flora Giffuni
15 Gramercy Park South
New York, NY 10003
212.353.3590

Henry Gillette
33 Battery Place
Crugers, NY 10520-1401
914.739.4988

Angelo John Grado
641-46 Street
Brooklyn, NY 11220
718.853.3244

Daniel Greene
742 Route 116
North Salem, NY 10560
914.669.5653

Don Grzybowski
5241 Cracker Barrel Circle
Colorado Springs, CO 80917-1801
717.596.6891

Barbara Haff
23-38 31 Road
Astoria, NY 11106
718.726.5061

Albert Handell
P.O. Box 9070
Santa Fe, NM 87504-9070
505.983.8373

Annette Adrian Hanna
6 Overlook Road
Boonton Township, NJ 07005
201.316.0857

Carol P. Harding
480 E. 500 N.
Pleasant Grove, UT 84062
801.785.2446

Mary Hargrave
6 Colonial Avenue
Larchmont, NY 10538
914.834.7586

Grace L. Haverty
Scottsdale, AZ

Janet Hayes
25 Arllinya Road
Healesville, Victoria 3777
Australia
61.359.62.4894

Janet N. Heaton
1169 Old Dixie Highway #5
Lake Park, FL 33404
561.844.3415

Sidney Hermel
511 E. 20th Street
New York, NY 10016
212.677.2969

Patty C. Herscher
17 Catalpa Court
Ft. Myers, FL 33919
941.278.0122

Willi Hoffmann-Guth
Rontgenstrasse 17
D-66123, Saarbrucken
Germany
0049.681.35294

Roz Hollander
5 Dogwood Drive
Newton, NJ 07860
973.383.4966

Claire Miller Hopkins
515 Glendalyn Avenue
Spartanburg, SC 29302
864.583.2227

Muriel Hughes
8840 Villa La Jolla Drive, #214
La Jolla, CA 92037
619.457.2879

Alice Bach Hyde
110 Ichabod Trail
Longwood, FL 32750
407.268.8655

Bill James
15840 SW 79th Court
Miami, FL 33157
305.238.5709

Mei Ki Kam
45-23 Union Street
Flushing, NY 11355
718.461.0424

Adam Kelley
82 Pennsylvania
Denver, CO 80203
303.765.4822

Anita Kertzer
Box 64, Winding Way
RR2, Ottawa, Ontario
Canada
613.825.4577

Catherine Kinkade
257 Midland Avenue
Montclair, NJ 07042
201.992.5065

Everett Raymond Kinstler
15 Gramercy Park South
New York, NY 10003
212.475.0650

David Lebow
27351 Palo Verde Place, Apt. 204
Canyon Country, CA 91351
805.299.2571

Jo Ann Leiser
145 4th Avenue, 7J
New York, NY 10003
212.388.1153

Ann Boyer LePere
6408 Gainsborough Drive
Raleigh, NC 27612
919.782.9764

Paul Leveille
135 Cross Road
Holyoke, MA 01040
413.534.5348

Joe Hing Lowe
36 Greaves Place
Cranford, NJ 07016
908.276.9664

June L. Maxwell
1450 Stockton Road
Meadowbrook, PA 19046
215.884.2401

Mary Beth McKenzie
545 W. 45th Street
New York, NY 10036
212.265.5382

Jody dePew McLeane
10241 Phaeton Drive
Eden Prairie, MN 55347
612.942.9969

Cheryl O'Halloran McLeod
1318 Belleview Avenue
Plainfield, NJ 07060
908.561.0406

Patrick D. Milbourn
327 West 22nd Street
New York, NY 10011
212.989.4594

Clark G. Mitchell
100 Firethorn Drive
Rohnert Park, CA 94928-1332
707.585.1467

Fay Moore
15 Gramercy Park South
New York, NY 10003
212.982.2840

Elizabeth Mowry
287 Marcott Road
Kingston, NY 12401

Rhoda Needlman
87 Derby Avenue
Greenlawn, NY 11740
516.757.8356

Donna Neithammer
80 Talbot Court
Media, PA 19603
610.891.0892

Barbara Ogarrio
2319 Burning Tree Road
Half Moon Bay, CA 94019
650.726.4278

Desmond O'Hagan
2882 South Adams Street
Denver, CO 80210
303.691.3736

Claire Paisner
102-30 66 Road, Apt. 17H
Forest Hills, NY 11375-2091
718.896.6421

Timothy Parks
P.O. Box 596
Kennebunk, ME 04043-0596
207.985.7455

Judy Pelt
2204 Ridgmar Plaza #2
Ft. Worth, TX 76116-2340
817.732.0207

Sara-Sue Pennell
6 Upland Road
Lexington, MA 02173
781.826.8180

William Persa
4828 Scenic Acres Drive
Schnecksville, PA 18078
610.799.2372

Alexander Piccirillo
26 Vine Street
Nutley, NJ 07110-2636
201.667.8057

Richard Pionk
1349 Lexington Avenue, 8B
New York, NY 10128
212.348.8991

Constance Flavell Pratt
23 Tiffany Road
Norwell, MA 02061
781.826.2501

Marilyn-Ann Ranco
211 Outremont Avenue
Montreal, Quebec H2V 3L9
Canada
514.495.2943

Mitsuno Ishii Reedy
1701 Denison Drive
Norman, OK 73069-7491
405.360.4068

Ruth Reininghaus
222 East 93rd Street, 26A
New York, NY 10128-3758
212.876.0358

Gail E. Robinson
9 Government Street
Kittery, ME 03904
207.439.0223

Diane Rosen
355 Ridge Road
Highland Mills, NY 10930
914.928.8318

Nicholas Sacripante
9411 Moorehead Lane
Port Richey, FL 34668
813.862.0518

Roger Salisbury
5 Pheasant Run Road
Pleasantville, NY 10570
914.285.8660

S. Allyn Schaeffer
29 Woodland Avenue
Fanwood, NJ 07023
908.322.2394

Margot Schulzke
1840 Little Creek Road
Auburn, CA 95602
916.878.7510

Jane Scott
1402 South Skyline Drive
Elkhorn, NE 68022
402.289.4363

Judith Scott
6658 South Gallup
Littleton, CO 80120
303.795.0805

Jo-Anne Seberry
2/12 Edna Street
Mt. Waverley 3149, Victoria
Australia
61.03.9802.2328

Peter Seltzer
87 Main Street North
Woodbury, CT 06798
203.266.5870

Dan Slapo
155-15 Jewel Avenue
Flushing, NY 11367
718.591.0464

Elizabeth Smith
P.O. Box 493
Mendham, NJ 07945
201.543.0109

Rae Smith
513 W. Country Club Drive
Egg Harbor, NJ 08215
609.804.0773

Lisa Specht
P.O. Box 163
Westtown, NY 10998
914.726.3989

Joel Spector
3 Maplewood Drive
New Milford, CT 06776
860.355.5942

Sally Strand
33402 Dosinia Drive
Dana Point, CA 92629
714.496.8976

Marion Strueken-Bachmann
444 E. 86th Street, 30G
New York, NY 10028
212.861.4135

Janis Theodore
5 Harbor Road
Gloucester, MA 01930
978.283.6211

George Thompson
215 East 201 Street
Bronx, NY 10458
718.295.7383

Dee Toscano
2559 Ward Drive
Denver, CO 80215
303.239.9006

Brenda Tribush
41 Union Square West
New York, NY 10003
212.633.8270

Lorrie B. Turner
14 Village Drive
Huntington, NY 11743
516.423.6595

Judy Vanacore
206 Lentz Avenue
Paramus, NJ 07652
201.265.8671

Duane Wakeham
218 Hoffman Avenue
San Francisco, CA 94114
415.826.8920

Jeff Webb
270 Lowndes Avenue, #117
Huntington Station, NY 11746
516.271.1215

Marie Kash Weltzheimer
2513 Woodruff
Edmond, OK 73013
405.942.2724

Suzanne Lemieux Wilson
7501 Solano Avenue
Carlsbad, CA 92009
602.395.3301

Madlyn-Ann C. Woolwich
473 Marvin Drive
Long Branch, NJ 07740-5003
732.229.3752

Dinah K. Worman
4496 NDCBU
301 Guyora Lane
Taos, NM 87571
505.751.4545

Rhoda Yanow
12 Korwell Circle
West Orange, NJ 07052
973.736.3343

Suzanne Young
22 Russet Lane
Halesite, NY 11743
516.427.1730

Frank Zuccarelli
61 Appleman Road
Somerset, NJ 08873
908.249.0199

Index of Artists